Temporalizing Space

Literature and the Visual Arts
New Foundations

Ernest B. Gilman
General Editor

Vol. 8

PETER LANG
New York • San Francisco • Bern
Frankfurt am Main • Berlin • Wien • Paris

Albert Cook

Temporalizing Space

The Triumphant Strategies of Piero della Francesca

PETER LANG
New York • San Francisco • Bern
Frankfurt am Main • Berlin • Wien • Paris

Library of Congress Cataloging-in-Publication Data

Cook, Albert Spaulding.
 Temporalizing space: the triumphant strategies of Piero della Francesca /
Albert Cook.
 p. cm. — (Literature and the visual arts; vol. 8)
 Includes bibliographical references and index.
 1. Piero, della Francesca, 1416?-1492—Criticism and interpretation.
2. Holy Cross in art. 3. Space (Art) 4. Visual perception. I. Title.
II. Series.
ND623.P548C66 1992 759.5—dc20 91-43126
ISBN 0-8204-1865-X CIP
ISSN 0888-3890

Die Deutsche Bibliothek-CIP-Einheitsaufnahme

Cook, Albert:
Temporalizing space : the triumphant strategies of Piero della Francesca /
Albert Cook.—New York; Berlin, Bern; Frankfurt/M.; Paris; Wien; Lang,
1992
 (Literature and the visual arts ; Vol. 8)
 ISBN 0-8204-1865-X
NE: GT

Art on front cover: *Annunciation*, from *Cycle of the True Cross* by Piero
della Francesca. Courtesy of Chiesa di San Francesco, Arezzo, and of
Alinari/Art Resource, New York.

Back cover photo by Roberto Celli.

The paper in this book meets the guidelines for permanence and durability
of the Committee on Production Guidelines for
Book Longevity of the Council on Library Resources.

© Peter Lang Publishing, Inc., New York 1992

Printed in the United States of America.

To Peter Baker, Sarah Webster Goodwin, and Gary Handwerk

ACKNOWLEDGMENTS

This book consists, calculatedly if disproportionately, of two essays brought into relation with each other by a common reference point, the work of Piero della Francesca. The first essay draws some conclusions about the painter's handling of space, especially with relation to implications about time, and especially in the cycle on the True Cross at San Francesco in Arezzo. The second consists of a series of speculations, or takes, about the function of space in our perception of various forms of art.

My debts are many for this work. It has been consistently fostered by the encouragement and support of Brown University and its Department of Comparative Literature, which has also provided a partial subvention to defray the cost of plates. I have benefitted from discussions at the three conferences where I presented segments of it as papers: the Modern Language Association, 1989; the International Association for Philosophy and Literature, 1990; and the Skidmore Conference on the Sister Arts, 1990. Figuring in two of these three conferences was the general editor of this series, Ernest Gilman, to whom I am indebted for very useful suggestions about the organization and expansion of the material. My work was very substantially helped by an appointment as Visiting Scholar at the American Academy in Rome during March and April, 1991, where the locus, the ambience, and the stimulation of interchange, fostered my ideas on this project. I am especially grateful to Michael Stanton, who pointed a way for me to a line of discussion I would not have found on my own. The staff and library of the Academy helped me in many ways, not the least of which was facilitating my acquisition of some of the plates

viii

for this volume. I am very grateful to Peter Baker, for careful and
acute criticisms that helped me refine an earlier draft, and to Irving
Massey, Aaron Rosen, and Clint Goodson. As always I am grateful
to my resourceful and accomplished research assistant, Dr. Blossom
S. Kirschenbaum, who has helped with everything from facilitating
plates, reading proof and preparing the Index to general editorial
suggestions. My wife Carol, a reverberant companion, was
consistently encouraging (or discouraging where appropriate!), and
to her sharp eye I owe much, including the point about the
resemblance of Piero's *Ideal City* to the glare and shadow of an
actual Italian city at high noon. We had the good fortune to see this
work again and discuss it in Urbino as I was completing the book.

CONTENTS

LIST OF ILLUSTRATIONS

Plates

Figures

Temporalizing Space

PART ONE

TEMPORALIZING SPACE: THE TRIUMPHANT
STRATEGIES

OF PIERO DELLA FRANCESCA

Temporalizing Space: The Triumphant Strategies
of Piero della Francesca

I

Piero della Francesca's work, and especially his cycle on the True Cross, raises, like all successful painting, the question of what the viewer is responding to when he devotes some of his own time to contemplating the particular organizations of space offered to his view. Broad, proportionate, mysterious, enclosing, rich in its colors, extensive and suggestive in its references, Piero's cycle draws the viewer in and opens his perceptions out in ways that create a sense of both austerity and abundance, both seeking and fulfillment.

So far as narrative substructure is concerned, following a somewhat unusual but still traditional text, Piero relates his series on the True Cross elaborately, and with ultimate coherence, to a legend that he makes dovetail at one crucial point with more ordinary iconography in the *Annunciation* panel. This original stroke delicately imports into the legend of the Cross the main Christian story that is rarely if ever included in representations of it, and certainly not in Jacopo da Voragine's *Golden Legend*.[1] And by running through legendary history in mounted segments from the death of Adam to the victory of Heraclius, Piero organizes time into space, or space into time, more either than the *Golden Legend* had done, or still more those more "primitive" painters who "naively" set the biography of a single saint in an overlapping sequence across a panel, a practice still followed by his successor Botticelli in *The Legend of St. Zenobius*.

Since we have no details at all about the initial commission of the previous decade to Bicci di Lorenzo, which Piero took over on that painter's death, and since the little already executed that might be attributed to that earlier painter has no relation to the True Cross series, we have no way of conjecturing that the somewhat out-of-the-way subject had in fact been stipulated. But even if it was, Piero gives it a narrative handling that forces the viewer to organize both it and the many figures shown in relation to it, much more than in the most nearly comparable series, Agnolo Gaddi's sequence in the choir at Santa Croce in Florence some sixty years before (1388-92), where to begin with the name of the church makes the particular subject matter much more central. Soon afterwards, indeed, still another cycle on the subject at another church of Saint Francis, in a chapel dedicated to the Cross, was executed around 1410 by Cenni di Francesco di Ser Cenni.[2]

Piero's panels are arranged as follows, as lettered on the accompanying diagram: [**Fig. 1**]:

A The Death of Adam
B Seth Obtains from the Angel the Tree of Life
C Seth Plants Seeds of the Tree of Life in Adam's Mouth
D The Queen of Sheba Adores the Sacred Wood
E The Meeting of Solomon and the Queen of Sheba
F The Burial of the Sacred Wood
G The Torture of the Jew
H The Discovery of the True Cross
I The Testing of the True Cross
J The Dream of Constantine
K The Victory of Constantine
L The Defeat of Chosroes
M The Beheading of Chosroes

N The Exaltation of the Cross

O The Annunciation

(The right side of the sequence [A-E, K] and the left side [I, M-N] are shown in **Figs. 1** and **2** respectively.)

These panels are first set in spatial relation to each other for matching. But then they represent distinctly separate and slenderly associated moments of time, unlike the sequence of the life of Christ or the life of some saint, where the very associations, and separations, elide into each other much more easily. In this new super-constructive act of putting panel together temporally and logically with panel, Piero has here firmly aided us by starting with a group where three closely associated moments are represented together, the scenes around the Death of Adam. And then in other panels the associated moments flow together, in each case with much less distinction, both visually and logically, than is usual in the serial presentation of a saint's life—or in Agnolo Gaddi's handling of The Defeat of Chosroes **[Fig. 4]**, as distinct from Piero's **[Plate 4]**. Piero has also aided us by allowing for variety: the battle scenes and some others are dominantly horizontal, whereas the panels at the back of the altar are vertical, and of smaller (but still ample) dimensions, with a notably strong variation of palette as well as of structure between the quadripartite *Annunciation* **[Fig. 6]** and the unified *Dream of Constantine* **[Fig. 13]** All this contributes to a super-construction, and after that to a super-immersion.

Marilyn Lavin, in her admirably comprehensive and precise survey of over a hundred paneled church cycles, establishes that simple narrative seriality is not predominant in them, and they are as likely to read right to left as what we think of as the more usual left to right. In this, then, since he begins at the right, Piero is so

far traditional.[3] Though Piero follows a traditional organization in other respects too, his cycle does so far more complexly than in most other cases, since in his arrangement there are elements of all four of her basic diagrammatic patterns. In general he can be said to follow a modified version of her most traditional pattern, the "double-parallel apse-entrance," since he does put the earliest episodes on the right wall, starting at the apse end of the nave—though at the very beginning he introduces her "boustrephedon" pattern as well, since the movement is first from right to left and then reversed from left to right: the top panel begins with the dying Adam at the right **[Fig. 5]** before the seeds are planted in the mouth of his corpse to the left; but then the panel below it **[Plate 2]** sets Sheba adoring the Cross to the left before she greets Solomon at the right. The temporal order on the right wall is in the simpler "apse" pattern, reading from top to bottom. But then, on the left wall, the latest, not the earliest, *The Exaltation of the Cross* **[Fig. 12]**, is at the top, preceded by the bottom. These very shifts bring Piero into a modification of the "cat's cradle" pattern, where an "X" is inscribed if the time-line is marked on the space of the panels.[4] This is virtually the case with the four panels on the wall of the altar, and as though subsumed in the two prophets by an earlier artist surmounting them (not in the diagram)—*The Torture of the Jew* (G) standing above the *Annunciation* (O), but opposite the earliest event of these four, the *Burial of the Sacred Wood* at the order of Solomon (F), which surmounts *The Dream of Constantine* (J). Further, in the four segments of the *Annunciation* panel, there is also an X, but it indicates simultaneity rather than temporal succession. Even the "festival" pattern followed by Gaddi at Santa Croce can be ascribed to Piero, following Marilyn Lavin, since the large, delimited

segments of his frescoes can also be contemplated "atemporally," fixed on as the moments of a Church festival are fixed on by looking at the representations that evoke it. It is particularly the third of these patterns, the "cat's cradle," that plays fast and loose with temporal sequence and realigns the viewer to the senses and correspondences among the panels that have thus been thrust out of simple order. Piero's order is so complex, indeed, that in Lavin's study of the whole millennial tradition of sequenced panels, there is no arrangement, or almost none, that cannot be subsumed under Piero's patternings.[5]

Piero arranges these frescoes elaborately, but he does not do so frontally, nor are the areas "up" and "down" of a simple significance. The sides, right to left, are equally important. The whole complex arrangement of this series three-dimensionalizes the work, adding the narrative associations to his varying mathematics of perspective. We move from panel to panel as we view them. but at the same time their unusual dimensions, and the unusual largeness of the figures, arrests attention on the individual panel. Piero sets the figures frontally in the individual panels by bringing them into close-up on the picture plane, achieving an effect at once more individualizing and more schematic than Masaccio, much as did Andrea del Castagno in his time or Philip Pearlstein and Alex Katz in ours.

Since it is the Church of San Francesco where these murals are spread, one cannot disconnect the Cross—absent in them at any point as a visual completion, while otherwise omnipresent and present specifically in the chancel Cross—from the image already codified for St. Francis by (pseudo?)-Giotto and others, the stigmata. But both of these are at best remote references to the frescoes before us.

II

The primacy of space for any art work or any work seen as one entails the proportional handling, its reference to and engagement of, and also its exaltation of, the body of the viewer, in a care for presentation that is not only mathematical, though for Piero it begins with a mathematical exactitude. The painter's work, indeed, when it is successful, touches on the deep connection between number and the spirit, attaining to what could be called, in Kant's phrase (though not in Kant's sense), "the mathematical sublime."

Piero della Francesca in particular, as it turns out, to the end of painterly vision, often subverts the mathematical perspective of which he was so peerless a theoretician in his time. In "The Story of the True Cross" Piero is as remarkable for varying his handling of perspective as he is for his mastery of a means towards achieving perspectival proportionality. These very variations, indeed, of unusual foreshortenings, for example, in *The Meeting of Solomon and Sheba* [**Plate 3**] juxtaposed against the careful, but singly instanced use of depth projection certainly in *The Exaltation of the Cross* [**Fig. 12**] but ambiguously in *The Queen of Sheba Adores the Sacred Wood* [**Plate 2**], point towards a thematic as well as a visual use of perspective in his work. And beyond this he could be said to be enlisting for something like combinatory thought the ideal of a higher sort of proportionality, an ideal for which the attention to the Golden Section, elsewhere enlisted by Piero, importantly stands.[6]

His cycle on the True Cross, placing the viewer at the central point of the altar, or slightly behind it "presumptively," thereby sets the immersive absorption of the spectator into a richly rounded

fulfillment, while at the same time enlisting the bravuras of constructive presentation, both narrative and visual, for which he was both a masterly practitioner and, for visual effects, an original theoretician as well. It should be observed in general that for temporal sequences like the presentation of a story—in Piero's case moments of time in the millennial legend of the True Cross from Adam to the Byzantine emperor Heraclius—a constructive apprehension of the single panel, and also an immersive apperception of it, precede the establishment of relations between one moment and another. Such cycles go well beyond Leone Battista Alberti's strictures about the spatial manipulation of the story, *istoria*, in a painting. Space, in any case, precedes time (except in the trivial sense that the constructive apprehension of the space of a single panel must be gradual). But then time, as it were, takes over. It predominates as the final reference for the bodying-forth of conjunctions that the viewer has apprehended.

We should not lose sight of the fact that, whether temporal or spatial, the references here are "wordless," with a corresponding partial, or even total, convergence of sense and reference. It follows, indeed, from this wordlessness that the viewer carries away the illusion, and then the reality, of a more direct apprehension of the story than the mediation of words can provide. A visual representation is also externalized, while not just serving to indicate its object, as words will do. The word "Sheba" gives an arbitrary auditory form to a mental association, "Ethiop Queen," before which the auditory impressions vanish. The visible Sheba in Piero's painting does not vanish but rests in the eye and governs it. The bodies painted alongside hers, too, like hers, stand in a virtual relation to the body of the viewer, and the painted bodies are made to bear a sense that encapsulates their time-rootedness.

The Piero who gave such exact attention to the mathematics of perspective can be seen here to have mapped not only the points of perspective within a given frame but also, and with a new proportionality, the spaces governing the relationship of frames to one another. In one typical arrangement for a central altar such as this, a single image, framing the devotional gaze, confronts the viewer: at the altar, a huge crucifix; or a triptych of conventional devotion has center, sides, and predellae all in fixed relationship to one another, sharing a common space and a common time; or at least they share related segments of a single temporal sequence. In such secular settings as Mantegna's Camera degli Sposi at Mantua of a couple of decades later, the surrounding pictures are somewhat randomly related to one another; the viewer stands in the beginning of a gallery. And in Giotto's still earlier Scrovegni Chapel, a traditional panorama is offered of the Life of the Virgin and the Life of Christ. In Piero's sequence, the subjects of the panels sweep through a long sequence of time, and they are connected as the single strand of one religious legend strings together its disparate events. The ideal position for viewing them all would place the spectator almost exactly at the very point of the Cross on the altar that he would (otherwise) be contemplating.

The Cross in these panels moves in and out of a visible presence. In the first panel (A-C) the Cross is present only as an invisible seed; in the second (D-E) as part of the blocked segment of a bridge. In *The Burial of the Sacred Wood* (F) it is a large, broad diagonal of lumber, absent again in *The Torture of the Jew* (G), though there its constituents are suggested in the tall triangled struts of the frame by which the Jew is hoisted. There are two extra crosses and the True one distributed through the complex geometries of *The Dis-*

covery and Testing of the True Cross (H-I). The Cross is all but absent again visually in *The Dream of Constantine* (J). Though the whole dream is of the Cross, and light from it may therefore be said softly to saturate the painting, the actual Cross is just faintly visible in a simple pattern just above the cuff of the angel, blurred white against the red of the tent, barely longer than the finger that the angel points in the opposite direction, or not even quite the opposite direction—at an angle of twenty degrees or so below and away from it, as though the Cross were floating away from the finger indexing it. Though this Cross appears clearly under ultraviolet rays, it could never have been very prominent because of its size.[7] In *The Victory of Constantine* (K), the "sign by which he shall conquer" ("In Hoc Signo Vinces") is a tiny white emblem, some inches high, held forward in Constantine's outstretched hand. Absent in the *Annunciation* (O), the Cross is a trophy laterally obscured in *The Defeat of Chosroes* (L-M), finally to be held up close to the center in the open space of *The Exaltation of the Cross* (N) in the high lunette at the top of the left wall.

The Cross, to begin with is an unusual relic. The normative relic is a fragment of something, or else a disposable item like a garment. Fragments of the Cross do lend themselves to enshrinement as relics, but the Cross represented by Piero is whole and entire. It has a central, but steadily metonymic relation to the Crucifixion, as anything connected with that event would have to have had in this world, since Christ himself was resurrected. The handling of the Cross in these panels emphasizes its lateral connection to events before and after, since, as traditionally in the handling of this story iconographically, there is no representation of the key event in the series, the Crucifixion itself.

And this particular relic has a special relation to time. The longevity of trees, and their reproducibility through seeds, is attributed, as it were, to the lumber of the Cross itself. When the Cross appears in this series, it is made to look fresh and new, as if exempt, in its trace through each event, from the processes of time to which the splendidly present human beings in each panel are themselves actually subject. In this Piero ignores the tradition, repeated in the *Golden Legend*, that the Cross was composed of four separate species of tree. In his representation it remains mysteriously and perennially fresh, through the whole millennial series.

III

Piero begins by following the *Golden Legend* more comprehensively and exactly than Agnolo Gaddi had. On and around the altar on three sides, Piero's set of panels disposes and historicizes the Legend of the Cross into a set of relatable functions, whereas in the *Golden Legend* these functions are randomly distributed, with much else, around dates in the Christian year, a devotional calendar that has its own absolute, predominant linearity.

The life of Christ is omnipresent, but virtually blank (except for the Annunciation) in these frescoes, whereas that life, or comparable lives, are the staple of other frescoes, and of Piero's other paintings.

However, as the *Golden Legend's* summary for May 3, "The Finding of the Holy Cross" makes clear, this text touches on many of Piero's panels (except *The Annunciation*) from Adam through Solomon and the Queen of Sheba down through Constantine:

Inventio sanctae crucis dicitur, quia tali die sancta crux inventa fuisse refertur. Nam et antea fuit inventa a Seth, filio Adam, in terrestri paradiso, sicut infra narratur, a Salomone in Libano, a regina Saba in Salomonis templo, a Judaeis in aqua piscinae, hodie ab Helena in monte Calvariae.

The Finding of the Holy Cross [this feast] is called, because on just that day the Holy Cross is reported to have been found. For it had been found previously by Seth, the son of Adam, in the earthly paradise, as is recounted below; by Solomon in Lebanon; by the Queen of Sheba in the Temple of Solomon; by the Jews in the water of a fish pond; and today by Helen on the Mount of Calvary.[8]

Much of this chapter of the *Golden Legend* is given over to recounting the episodes around Constantine's conversion and victory that are represented in Piero's panels. In his later chapter on the Exaltation of the Cross (September 14), the writer gives a fairly full account of Heraclius' victory over Chosroes.[9]

In the *Golden Legend* a potpourri of items from sacred history, largely from saints' lives, is organized linearly around the Church Calendar. This difference between its vast miscellany and Piero's focussed series of panels makes it indifferent whether or not he read the *Golden Legend*, although the high intelligence of this creative mathematician would increase the likelihood that he had. The Story of the True Cross in any case not only frees him from the calendar. It frees him from the simply and traditionally figural; and even the one case of such possible correspondence, between *The*

Queen of Sheba's Adoration of the Cross and the later *Exaltation of the Cross*, is far from traditional. They are figural, so to speak, only in a random sense. This randomness puts the narrative line, and its connections, at the center of perception. The artist does not have the life of a single saint and its episodes, or the life of Christ, or even the panorama of Church history to fall back on.

The actual Cross, absent in most of the actual frescoes but fixedly present as a crucifix on the altar, may be conceived of as a center from which the unfolding history of the True Cross is put visually, and intellectually, together, an often invisible presence in constant relation to the visible moments of time represented in the frescoes.[10]

Again, in the sequential presentation of saints' lives according to a medieval pattern, many episodes are strung together on a single panel—as here, too, happens, in different moments of *The Defeat of Chosroes* (L-M), and in *The Burial of Adam* (A-C), and in the Embassy of Sheba (D-E). But these intra-pictorial sequences are squared off for the inter-pictorial, larger relationships, as does not happen at all in the panorama sequences of such Sienese painters as Duccio, and still less in the easy sequences of a later painter like Pinturicchio. Those of Piero move severely and broadly through epochs of time, jumping as well as juxtaposing and intercalating from the source series of the *Golden Legend*. Here, the unfigural spread across time of a large history at which the key points are randomized, as well as redeployed in large, schematic, Uccellesque figures, matches the subliminal presence of the actual cross or the actual Christian story on this altar, in this chancel, as against the randomly connected set of comparatively random anecdotes it concatenates.

IV

In other works Piero seems simultaneously to display and to subvert perspective. In the San Sepolcro *Resurrection* something more complicated than a singly oriented perspective brings Christ forward in a space not visually anchored to all the other cues and so he is "too large."[11]

The richly clad figures mirrored in the stream and so perspectively emphasized, are at the same time too small in the London *Baptism*. God, in the upper left-hand corner of the Arezzo *Annunciation* panel, is represented without special perspectival adjustment to the other three segments, and the Virgin is too large for her chamber. In the *Resurrection*, the soldiers are a complicated tangle, as also in *The Defeat of Chosroes*. In this battle the diversity of persons is frontally organized. The distances of Uccello are *not* called on (even if Vasari is right that Piero learned from him).

Now Masaccio's *Tribute Money* is also an unusual choice of subject. It is worked out on the "circular plan," one that was very widespread.[12]

If we compare the complex "opening out" of Leonardo's *Adoration*, to Piero's cycle, or those of Gentile da Fabriano and Lorenzo Monaco, or the panoramic works of Fra Angelico, the measure of Piero's elaboration emerges as firmly linking its spatialities to a large temporal sequence. The breakdown of subjects in his *De Prospectiva Pingendi* is also suggestive for the figures in his cycle:

> In the first [book] we shall speak of points, lines, and
> planes. In the second of cubes, four-sided pilasters,
> and round and many-sided columns; in the third of
> heads and capitals, twisted bases, other bases, and
> other objects in different position.[13]

Nearly all these geometric figures are found in the True Cross fres-
coes, but they are not used in any simple way to cue us towards
regular perspective, as the slanted lozenges elaborately are on the
floor of Piero's *Flagellation*, where the architecture of the setting
can be diagrammed from Piero's slender but precise cues.[14] Hubert
Damisch links the successive "subjective" positions implied in Pie-
ro's treatise to his own handling of perspective in his works—and
certainly the successive positions are more remarkable in the True
Cross series than are the more usual Renaissance manipulations of
distance within a single pictorial frame:

> A demonstration, and really one of the strangest for
> someone who wants to understand it. It supposes
> that a point A, to be called the eye, is marked at the
> center of a square, and that the diagonal of the
> square will divide into four equal parts—a curious
> "point," which can be divided into quarters, each of
> which could in turn be considered as a separate
> organ.[15]

Damisch goes on to conclude that the result of such division would
be to set the viewer up at an angle of relationship to a whole paint-
ing rather than just to calculate the perspectival lines within it.[16]
And he connects Piero's theories (and potentially his practice) to
modern mathematical speculation:

> So again this rule, appearances not withstand-
> ing, is not based on the anatomy and physiology of
> the eye. ... Piero [would seem to have] held the
> binocular connection for a deformed vision, where
> the two eyes are situated on a single line, with the
> astonishing schema that Piero proposes, in which the
> perspectival field offered to an eye is perpendicular

to the one for the eye adjacent to it. Taking it for
what it is, Piero proposes no less a problem than one
of the same order that occupied a number of minds
at the beginning of the century, such as Mach or
Poincaré, Russell or Carnap: What is the purport, in
the representations we form of space, of the relation
between the *given* and the *constructed*?[17]

The viewer is fixed for constructive apprehension of the
work, but his perspective operates to shift his vantage, just as
prominently as it engages vanishing points, in this space where it
could be argued that in any case no fixed viewpoint could wholly
organize the frescoes perspectivally. And Damisch's adduction of a
doubling in Piero's space between the *given* and the *constructed* could
be mapped onto the doubling between spatial blockings and tempo-
ral sequences. As he says:

> The usage Piero makes of geometry here, so as to
> prepare the reader for his articulation of the double
> limit to which the painting is constrained, witnesses
> very eloquently to a confusion Wittgenstein was to
> denounce between two languages, each of which has
> its own grammar and syntax: the one of visual or
> phenomenal space, and the one of geometric or phys-
> ical space. Two languages whose discourse under-
> lines the difference through the distinction operative
> between "being" and "appearance" considered from
> the same angle—two quantities will *seem* equal that
> *are* not. That is, the frontiers of the painting will
> correspond to that of a field where reality and
> appearance are equal, and truth and seeming.[18]

In other works Piero matches on his own the "plateau composition" of Jan Van Eyck.[19] Masaccio, by contrast, diagrams but does not block his figures. In him there are details "left over," whereas in Piero there seem to be none.[20] Piero has these large blocks themselves build the world—as did Cézanne.[21] Color, too, a subject Piero names but does not return to in his treatise, is made in this series to work in large blocks. So in *The Victory of Constantine* [**Plate 1**], for example, the white, black, brown, and grey horses are set off largely against each other, and they are almost rhymed with surrounding garments—as this range of colors is used above the *Victory* panel for the four horses in the train of the Queen of Sheba. The blocks match within one panel, and from panel to panel.

The ideality of this complexly organized space and its centering becomes apparent if we ask how and when the viewer could have been in a position to experience it. In the clericalism of the fifteenth century, the chancel, the space set off around the altar, was reserved for the clergy. And even they would have been occupied with liturgical duties when there. Some frescoes, on the other hand, like those presumably by Giotto along both sides of the nave in the upper church at Assisi, or those of his in the Scrovegni chapel in Padua, can be taken in at the angle of the worshipper. In this way the chancel differs from the side chapels, though they too, of course, in their usually smaller space, are set up to be used for religious services. And typically the mosaic panels in Italian Byzantine structures like San Marco in Venice or the Baptistery in Florence are visible at various points in the edifice, not just at or around the altar. But the complexity of the individual panels and their relations in Piero's "True Cross" would strain the viewer, even if he were not, as characteristically, preoccupied with religious duties. And if

he were not a priest, he could not stay near the idealized center at the altar—which again, strictly speaking, is reserved for the very Cross, this time a full crucifix, that furnishes the subject matter for the frescoes.

All this is very different from the spatial orientation implied by the large crucifix one finds in certain churches, like that of Cimabue in Santa Croce, which do face the worshipper, or like the iconostaseis of Orthodox churches, presenting panels to be taken in by those in front of the screen while the clergy carries on its liturgical actions behind it. In a sense, only the painter is here in the social situation of physical position and assigned disposition of viewing time to take in the work—and this means that the viewer from the beginning, like the modern viewer, is asked to reconceive the painting. This would be all the more the case when we remember the elaborate attention given to what amounts to viewing angle in Piero's theoretical works. As Roberto Longhi well says, "through binding these ancient corporeal proportions in a depth walled up by positive intervals, a metaphysical sense can be reached of a more complex cosmos of appearances ... Metaphysics, or dream, rose as if immediately from the new enthusiasm for the new spatial certitude."[22]

Reinforcing the virtual body orientation where the speaker occupies the position of the sacrificing priest below the crucifix is the body that will be receiving from the priest a communion of the transubstantiated body, "This is my body." The cross that is freighted with Christ's body above the altar is never freighted with such a body in these frescoes, but there is an analogue to the placement of the communion wafer in the mouth of the communicant when Seth places in Adam's mouth the seeded branch that will

become the tree of the Cross. This reversal and variant of the father-son relationship on the upper right wall echoes that on the middle left, where the son is absent and parodied by a slender cross at the right hand of Chosroes' throne. Chosroes' throne is vacant as the Persian king kneels, humbled, just before not a natural death like that of Adam—though both are quite old—but the violent death of execution [Plate 4]. This amounts to concentration as well as to analogy, if it is recalled that Piero omits any definite graphic depiction of the defeat of the sons of Chosroes, the subject of a panel in Agnolo Gaddi's "True Cross" series. And bodies are sharply and violently executed throughout this panel, receiving a contrasting treatment in other panels. The body of the Jew is being resurrected from the well, that of the Virgin is conceiving through the Annunciation. And that of Constantine, surrounded by his light-bathed open tent, is receiving the dream of the Cross [Fig. 13]. This dream comes through the wall of the tent. The angel has released it on the slope of the roof on the outside of the tent, as though in penetrating the tent it will include the whole scene of this panel, which it may be taken to light up, in the dream of Constantine, and implicitly to question the relation of the nature of the body to the dreams it may have when it is asleep to itself. Constantine here stands towards his dream, then, much as the viewer of the sequence stands towards him. As in Carpaccio's later dream painting, *The Dream of St. Ursula*, an even light bathes the scene, as though to clarify, but also to sublate, all the intricacies underlying medieval dream theory.

In one panel a body is physically lugged out of a well, in another a body is spiritually brought back to life, and this is a proof that the particular Cross effectuating this resurrection is the authentic one. The favored among all these bodies will presumptive-

ly be included with the viewer in "the mystical body of the Church," a doctrine to which the Cross furnishes a necessary leverage.

Taking measurements from the calculated fixed point of an observer's eye and organizing material thematically with respect to a central observer—these two procedures, perspective and observer-organized thematics, are quite naturally associable to each other. Leonardo, however, cannot be said to have attempted the second, which can be seen to be a preoccupation of Piero, Leonardo's crucial predecessor in the science of perspective, working here under the difficult condition where no single point of observation will be the ideal one for all the panels.

In these large panels ideas come through obliquely, like whatever the white-hatted Mongol soldier may be said to stand for, who thrusts forward prominently in Heraclius' battle. And all the moments of this story are oblique as they relate to the actual Crucifixion—Adam, Sheba, Solomon, the Virgin, Constantine, and Heraclius. Always Christ himself is *absent* from this Cross in space *and* in time. And this absence is caught in the disposition of panels where the Cross is shown.[23]

The very absence invites the viewer to seek connections, and so to speculate on matchings, of Sheba with Helena, of Constantine with Solomon but also with Heraclius, of attendants with attendants. Such iconographic congruences, however, would always carry well beyond the traditional figural ones of Old Testament and New, to much greater elaboration than, for example, Hans Graber[24] speaks of, who matches battle to battle, Sheba to Helena, the Planting of the Tree to the Discovery of the Cross, the Annunciation to the Dream of Constantine, and saving the Cross from water to pulling the Jew from the well. At the same time Piero's cycle does offer

an unusually rich array of typological matchings of the conventional sort between Old Testament and New, and of figures from sacred history with both.[25] Still, Piero's cycle stands in a firm obliquity to these more conventional references, serene in the predominance of its own rich and richly related presentations.

For an effect that submerges the iconographic in the visual, as Kenneth Clark says, "the bloody battle of Heraclius is set against the bloodless battle of Constantine," "primitive life is followed by the restrained splendor and decorum of Solomon's court; the night-scene of Constantine's dream is followed by the dawn-light of his victory, and the severely static scene in which the Cross is discovered and recognized is in contrast to the confused and jarring battle below it."[26]

I shall elaborate further below on the two battle scenes and on the contrasts between them. Since there are only two, one might go on to match the two scenes pendant directly to them, *The Dream of Constantine* for *The Victory of Constantine* and *The Exaltation of the Cross* for *The Defeat of Chosroes*. *The Dream of Constantine* is private, enclosed, and aimed to an immediate and also to a remote future: What the angel announces to Constantine, "In Hoc Signo Vinces," can be taken as carrying well beyond the battle: it is, however, a thought. *The Exaltation of the Cross* is public and open, aimed at celebrating what has already taken place. As the very last in the series, also, it is resumptive, as *The Dream of Constantine* can only be if its idea is extended. Moreover, this last in the temporal series, *The Exaltation of the Cross*, is charged by Piero with meanings that link it also to a prospect through the arrival of the king, and to a religious humility associable to the Saint Francis for whom this church is named: "Piero's scene is set outside the town and the

gate is omitted...Representing the episode this way as an isolated scene, Piero has alluded to the ancient protocol of *adventus*, wherein the farther the greeting is from the city, the greater respect is shown ... Showing Heraclius simply dressed and barefoot, moreover, makes his act a premonition of discalced poverty, chief among Franciscan virtues."[27]

It can further be said that the twos (and juxtapositions) are further counterbalanced by threes: Constantine, Maxentius, Helena; Seth, Angel, Adam; Sheba, Solomon, attendants. Carlo Ginzburg, who convincingly argues that such schematizations are empowered by Piero's very departures from the *Golden Legend* which Gaddi had followed faithfully, relates some of the thematic material in this sequence to the prominence at the time of negotiations with the Eastern Church and its representatives, whom he traces in a precise calculation of probabilities into the milieu of Piero. Ginzburg strikingly matches parallels of depiction between his Constantine and Heraclius (and also of the negroid attendant of the Queen of Sheba), and Pisanello's two medals of Constantine and Heraclius.[28] Yet such contextual siting only begins to account for the matchings in Piero's series, and such speculations are modified by the presence of these motifs in earlier representations, and even in the Stavelot reliquary.

Looking at the series not in its sweep of history but thematically, in the absence of the given figural correspondences of Old Testament with New, it establishes its own correspondences, partly by the rhyming of represented bodies, partly by the position of the panel in the whole sequence, and partly by logical associability. *The Burial of the Sacred Wood* at the order of Solomon (F) is set in cross association at the back of the altar with *The Torture of the Jew* (G)

at the order of Constantine's mother Helena to reveal where the Cross is buried. Helena stands in some ways to Constantine as Mary stands to Christ; in addition to being his mother, she is a sort of background religious sponsor. This connection puts the other two panels here, that of *The Annunciation* (O) and *The Dream of Constantine* (J), into thematic association, when the subject of annunciation with a small "a," so to speak, already carries through that association. Constantine's Kingdom is very much of this World (a thematic contrast), and his worldly victory is shown laterally, or in cat's cradle, in the bottom panel on the right. But the angel announces to him in the dream that takes place in a mysterious light within his military tent the great motto, "In Hoc Signo Vinces," "In this sign you shall conquer." That sign, of course, is the sign of the Cross—just the bare sign, not the Cross itself, of which his mother by legend has not yet completed the discovery. The victory will allow him, according to another legend not yet exploded at the time, to execute the Donation of Constantine and to found the Holy Roman Empire that is still very much an active force in the world of Piero.

There are matchings everywhere. If the rudeness of the Adamites contrasts sharply with the courtliness of Sheba and Solomon, and if the aged, abundant nudity of Eve, startlingly depicted by Piero, contrasts both with the stylish clothing of the queens in their prime,[29] Helena and Sheba; and also with the grace of the young Mary (Ave Eva); then the earthly queens and the queen of heaven can match each other. Starting with this Eve in space and in time would permit us to follow Adrian Stokes in cueing a Kleinian relation of apprehending a painting in general to the dream of the body of the mother, and the more so for a painter who unusually took his name from the mother who raised him.

And in any case the whole Adamite panel of the top right, all of its three episodes, can be matched and subsumed at the top left in *The Exaltation of the Cross* (N), the final panel of the series with the first. *The Victory of Constantine* (K) can be matched as well as contrasted with *The Defeat of Chosroes* (L-M), and *The Discovery and Testing of the Cross* (H-I) can also be matched and contrasted with Sheba's instinctive, perhaps sibylline hesitation before the wood in the bridge, thrown there because it magically changes shape when Solomon would fit it to his temple (a failed "discovery" and a muted "testing"). Finally both panels may be linked with her presumably secret communication to Solomon of what that wood might be destined for (D-E). The differences of time and sense are underscored by spatial proximity: Adam to Sheba, and also to Constantine; the Exaltation to the Discovery; the Discovery to both Solomon and Chosroes. And the time sequence is queried, but not exactly reversed, in the juxtaposition of *The Annunciation* and *The Dream of Constantine*. The spatial organization permits the establishment of all these connections and allows them to surface, for the immersive apprehension of the viewer. A perspectivizing of the individual scenes would "draw off" the eye into a distance, as in the sharply proportionate distancings of the London "Baptism"[30] and in the elaborate structurings of the Brera *Madonna*. The thematic matchings establish continuities through the long time of the legend. But in addition to such *matchings* as Heraclius and Constantine, or of both with Solomon from episode to episode, across a whole millennium, there are *discontinuities* from episode to episode, all around the central discontinuity of ignoring what usually goes at the center of an altar at this time, the Crucifixion.

Here, in a sense, the perspective is at the service of the nar-
rative, and vice versa. The substitution of three sides, and a super-
session of arches, for the frontality of a single wall or even a single
ceiling, sets continuity and discontinuity into the very space of view-
ing: it is continuous, in so far as the centered spectator is immersed
in the scene and caught in the ranges of angles that Piero himself
discusses in *De Prospectiva Pingendi*. It is discontinuous in that
each of the three sides is distinct by itself. And in the narrative
presentations, too, discontinuities are strikingly present as we jump
from Adam down to the Queen of Sheba, or even across the altar
from Constantine to Heraclius. But, supplementing the threads of
thematic continuity and qualification posited by these juxtapositions,
there are bold continuities as in a single panel one scene shades into
another, the voyage of Sheba with her meeting in Solomon's court,
Adam's dying with the planting of the seeds in the mouth of his
corpse. Seth, gone back to Paradise for the Oil of Life, returns
according to the legend with the three seeds from the Tree of Life
that he plants with a branch in Adam's mouth in the top panel. In
the legend, though Piero does not pick up this sequence for repre-
sentation, the trees that grow are uprooted by Moses, turned into
magic wands, inherited by David who binds them into one staff that
is replanted to become the tree that Solomon tries to place in his
Temple, but it will not fit. Before that, in another strand of the leg-
end, this very timber forms a bridge that the Queen of Sheba, ador-
ing its wood, refuses to walk on in Piero's panel below, as he picks
up the legend again through a long stretch of biblical time. Sheba,
identified or fused with the Sibyl in another strand of the legend,
prophecies to Solomon that it will cause the death of Christ (or, in
another version, trouble for the Jews). These different strands of

legend are evened out in the two panels that group the Solomon and Sheba legend itself around the future Cross.[31] In the continuation of the legend, the tree is buried, then resurrected to be used for the crucifixion, then buried again before its relocation as indicated in the panels of Piero's cycle. The long range of time, caught in the distance and dispersion of one panel from another, half-suppresses, but thereby also curiously emphasizes, the narrative connection, which is the same time "spatialized" within a single panel by Piero's suppression of details that the *Golden Legend* and other painters had represented.[32]

The discontinuities, thematic and visual, are highlighted and qualified not only by such continuities but by the visual *blockings*, in which within a given panel or group just a few persons (*The Torture of the Jew, The Annunciation*) or even horses (*The Victory of Constantine*) are blocked. The proportionate space, and the unusually light use of markings of separation from panel to panel, serve to block in the figures, and also by extensive association the whole of each panel, as though it were a fully realized integer in a sum, an analogue to a word in a sentence.

It might seem that "blockings" would not be a separate category from the subjects of the panels, above and beyond the narrative force of each panel. And yet there is a visual communication of fullness that Piero's attention to spatial segmentation creates. That communication, too, is not simply visual; its attainment is not just what an artist in mosaic would produce by comparably filling in his space; nor is it what either Masaccio or Giotto, for example, bring about in the variety of their attentions, to facial features or to drapery. These artists leave "open space" whereas Piero's plotted space encloses each segment of the field, and the differentiation of

segments amounts to a convergence of the visual with the significa-
tive: we read the blockings in a way that hinges with the continu-
ities and with the matchings, though the blockings are distinct from
these other significative procedures just because they could stand
without the particular reinforcement, and also the qualification, the
blockings offer. That is, in the domain of implicitly temporal conti-
nuity and narrative signification, the Queen of Sheba is of para-
mount importance as she adores the wood. But, in the blockings her
horses, her handmaidens, and the wood itself, assume an impor-
tance that, because they are blocked, convey an interlocking "para-
tactic" sense of equivalent significance to each, as a semiotic ground
for the counterpointed figure of hierarchized significances. In the
domain of blocking the handmaid is as important in the viewer's
eye as is the Queen—so much so that not only in the Sheba panel,
but also in the panel with the similar Helena, and in others, the eye
does not immediately pick out the key figures. And this evening-out
through blocking cannot be dissociated from signification.[33]

In a sense what I am urging is true of all art, but Piero has
underscored it in a special way, a way that depends, again, on the
keenly managed deployment of hinging significations.

Here space becomes supreme, the blockings are paramount.
And the space links through the time of what the space represents,
the continuities through time and matchings, and the very disconti-
nuities, entering into the convergence of these blockings as they are
all evened together for the eye. Something like Adrian Stokes' aus-
tere "Quattro Cento" effect has been achieved, the large and still
celebration of an underlying and perceived wholeness in the spatial
representations, a something that endows the randomness of this
particular legend with the seal of perceived inevitability.

So the Queen of Sheba—an unusual subject for a painter to include from the legend—[34] stops at the bridge, to adore the wood, but it is as though she has gone over the bridge, because in the next panel she is bent at almost the same angle, in a white robe rather than a blue, but veiled identically; she as it were "faces herself." The wood of the bridge is blocked as the panels join **[Plates 2 and 3]** against the full-length Corinthian pillar, grained wood blocked against fluted stone. She is blocked kneeling, and again blocked standing across the double blocking of bridge against pillar. Solomon is blocked, and his attendants are blocked, as her attendants were in the adjoining, continuous panel to the left, as her horses are blocked and the trees there, and the pillars in Solomon's ceremonial court. And Crucifixion vs. Temple is encapsulated but sublates New Testament (dim prophecy) vs. Old Testament (actualization of the Temple and the actuality of its presentation).[35]

In *The Testing of the True Cross* (I), Piero avoids presenting here the Third Cross, that of Christ. We see this with "Discovering," however, on the far right in its miraculous function of the resurrection of the young man, to which Helena and her entourage reverently attend.

Whatever correspondences we may establish between one panel and another here, they are freed of the correspondences of thematic congruence, which become secondary with respect to the somewhat random narrative structure, as it runs from the death of Adam to the sixth century A.D. In thematic terms, the connection is emphatic, but also slender, from the Adam panel to the panel of *The Adoration of the Cross*.[36] There is simply the rather subliminal connection whereby ceremony and power and military action and royal preoccupation and the remotest of holy legends (Seth) connect on

the thread, slender but sure, of the True Cross, just as the observer, placed putatively by the concatenation near where the Cross would stand, is stabilized and connected to congruences in millennial history.

Their framing and foreshortening and perspectival handling give these imposing figures the look of *figurae*, while the angle of the narrative, and also the angle of the perspective, divorces them from the schematically figural. They are the more boldly spatialized, and then in another movement their very spatialization "melts" into the narrative moment. The very fullness and implantation of the detail holds them from the characterizing meditation of Masaccio, to expand them into a more profound meditation, where spatiality does duty for connectedness. The tightness of the picture plane—remarkable in the painter who had already created the distances of the *Baptism*—and the close-up largeness of the individual figures, hieraticizes and seals this figural appearance. By contrast the large figures of Andrea del Castagno, whether divorced from narrative or connected to a traditional episode like the Last Supper, are merely illustrative, visions of bodies. Fra Angelico disposes his space into an elaborate and centralized celebration, where in the Brancacci chapel Masaccio darkens his into stresses. There is a sense in Piero, by contrast with the dark play in Masaccio, of a plenitude of evened reference sealed into his frontality, of absolutely no leakage of the real, or to put it differently, none of the superfluous detail giving, obliquely one might say, an "effect of the real." In Piero's work here few if any details are oblique or superfluous with reference to others, but an entire panel is oblique with reference to its stage of the legend. Yves Bonnefoy urges that Piero uses perspective to cut through the opposition between the transient and the timeless to present a conceptual essence of time.[37]

Piero does open up the sky around and above his people, setting forth a continuous flow between green trees and brown ground, architecture and open sky. As Bonnefoy says (23),—and it is especially true of this series—Piero "refuses openings and vistas and disguises vanishing points." Still, a white-bearded, blue-draped God the Father rides a cloud in the blue sky squared into the upper left segment of *The Annunciation* [**Fig. 6**], balanced below by the angel whose red-purple robe nearly rhymes with God's undergarment, as his open hands vary the two raised fingers of the angel. A simple goods delivery loop on the right, and the plain arch of the building to which it is attached, balance God to the right, while in the right asymmetrically squared segment below, the outsize Virgin stays inside the Corinthian columns of a loggia on the same building, in another shade of red under a mantle of another shade of blue, backed by an elaborate red and white diapered pattern under the arch.[38]

Here a normally triadic scene is skewed and flattened into a quadripartite scheme: Angel, Virgin and, somewhat less usually, God the Father. The fourth quadrant, deliberately set in an asymmetrical pattern that advertises its own assimilability to symmetries, is the hoist mechanism and pierced wall set above the Virgin's loggia.[39]

The quadripartite scheme here, it would seem, touches profound chords for Piero, since, as noted above, he defined perspective from a projection of quartering the field of vision—and Vasari interestingly recounts a quartered vase as one of his remarkable early triumphs, "especially a vase drawn in quarters and facets, seen from in front from behind, and from the sides, the bottom and the mouth." Everything in this *Annunciation* is close to the picture

plane, and sharply different from Piero's other, later *Annunciation* in Perugia, where between Angel and Virgin is interposed a lengthy many-pillared and -arched colonnade that recedes elaborately to a distant, flat marble wall.

The abundant trees which he adds here and there to the scene, beginning notably in the Adam panel, are both schematic and naturalistic. They set a Nature round the events, a Nature sharply depicted in the carefully rendered grain of the large slabs of the Cross being upended and buried in the Burial panel (F). And the remarkable external urban architecture of the towns behind *The Testing of the Cross* and around *The Finding of the Cross*, the internal domestic architecture of the *Annunciation* and the court architecture of Solomon's palace, locate these settings schemically, rather than just naturalistically, in a geometricized world social as well as physical, one that recalls Piero's *Ideal City*. Agnolo Gaddi, who represents much more prominently the architectural settings for his series, does so far more inertly and less thematically. They are merely frames, where for Piero they are rendered into presences. When Piero melts the frames he throws the bodies into greater prominence, and induces to a complication of them that preserves an air of mystery, because, especially for such an out-of-the-way legend, the narrative element does not just rest on a mere communication of the story: there is little of the "Biblia pauperum," the bible of the poor, here, where the visual substitutes as an indicator for those who cannot read. The visual presences of these bodies do not serve as cues for narrative integers but as radiant sources for evocation and impression, for the contemplative assimilation of richnesses in the evoked moment, a moment to which the narrative is a necessary but residual and somewhat sublimated armature.

As again Roberto Longhi says, speaking of Fra Angelico, the earlier painter "would be astounded to see Piero transform the scene into a vision of an unperturbed humanity in an unperturbed architecture, where the Christian fact appears as a minimal, lustrous spectacle, placated by its ambience and its almost predestined decoration."[40]

Reinforcing the emphases of Piero's presences in each panel is his variation of the space distributed around them. Figures in a frame can be crowded or sparse, relatively busy or relatively inert. Not only in minor work like Gaddi's but normally in panel sequences, the number and arrangement of persons from panel to panel is at roughly the same level of busyness, or there are compensations, as the intensity of Eve in one of Masaccio's panels may be said to compensate for the greater crowding, but also the greater quiet, in *The Tribute Money*. Piero, however, boldly frees himself from both a steady level of busyness and a simple contrast of busyness with repose. The attention to such distributions in Piero's sequence covers a wide range, from the pell-mell crowding of *The Defeat of Chosroes* to the sombre isolation of *The Dream of Constantine,* and the arbitrariness of the shift along the range serves to underscore, as we match one panel to another, the significance of the space in each individual panel.

In the Adam panels (A-C) their jumbling of time sequence, uniquely, and their tight elision one scene into another, reinforces the legendary quality with which the long initial time here is represented, the varied figures overarched and qualified by the sameness of the tall trees growing behind them. A stateliness spreads out the figures in the Queen of Sheba panels (D-E), coordinating them quite harmoniously with the trees in the left panel and the interior archi-

tecture in the right, as differently from the trees in the Adam panels above. The Burial and Torture panels (G, H) group a few figures around an active center, while the "Discovery" and "Testing" panels (I-L) arrange their stately personages in the complexities of two architectures turned at an angle to each other, the *Discovery* crowding its figures against an open terrain and a whole, distant town, while the *Testing* crowds the figures even more in the equally crowded, busily distributed, spaces of a town square. The tent that envelops Constantine for his dream (M) expands the space, and the time also expands, of the unmarked moment and the far significance of his dream. The quiet, perspectivally shrunken, space of the river bisects the warriors loosened on both sides from their battle in *The Victory of Constantine* (K), while a larger space at the center, and also around the sides, holds in a coordinated vastness the two groups of *The Exaltation of the Cross* (N).

V

If we are candidly to assess what we find of artistic value in this cycle, there is the particularly puzzling case of the two battle scenes, *The Victory of Constantine* **[Plate 1]** and *The Defeat of Chosroes* **[Plate 4]**, with relation to each other, and with relation to the rest of the series. We should ask about both our artistic apprehension of battle scenes generally and about Piero's handling of space and other features in these particular ones. For us, in our somewhat alien culture, there is the prior question of the subject matter itself, towards which our posture and the grounds of assimilation are likely to differ from those of a culture that especially honors battle. For

these paintings in Piero's cycle Eve Borsook has adduced formal antecedents in ancient Roman battle sarcophagi, Amazonian battle reliefs, and reliefs on the Arch of Constantine, as well as scenes on cassoni, but beyond this such scenes are widespread in all the cultures of the Near East, and elsewhere.[41]

Battle scenes go very far back in Near Eastern art and its derivatives; they are found in the third millennium B.C. on Sumerian stelae and Egyptian friezes, and then, through probably unbroken succession, on Mycenean reliefs. They are favorites for such temple sculptures as the bas-reliefs on the Parthenon, they dominate Assyrian and Babylonian art, and they were widespread in Roman art from early Republican times.[42] The common iconographic motif of the massed battle continues on Roman Imperial triumphal arches, Byzantine trays, and many other places, down to the aestheticizing showpieces of Uccello and Pollaiuolo. Within all those cultures, making allowances for particular interconnections in their mythic systems (and especially since the ones on the Parthenon and elsewhere represent legendary rather than actual battles), the battles signify, celebrate, and invoke predominant power. They are jingoistic in a way I believe most modern viewers cannot easily be, and certainly not for some culture remote in space and time.

Now in one sense this is a naive or obvious point to make, but it is a puzzle as well as a considerable stumbling block to theoreticians who would posit a principle of congruence between our ethical ideals and those of the artist, visual or verbal. It is possible to get from the dominance of hostility in this thematic tradition to a theory of an interconnectedness between hostility and any human activity whatever. The most commanding attempt to do this in our time is René Girard's theory of a reciprocity of violence deriving

from a depth motivation to assert and erase a difference between individuals or groups, a difference postulated to erase a sameness felt to be intolerable. Girard's theory is not only circular, as it must be; it is also gratuitously exclusive, even at the cost of equivocation about the transcendence by a Christian ideal of this depth principle, so that he comes out as a kind of Tertullian offering a modern version of a *"Credo quia absurdum."* [43]

One route towards accommodating violence in this series of Piero would be to meliorate and temporize the hostilities by the final triumph of Christianity. A Christian view in his series, it could be argued, is the more central for being kept marginal in this iconography: not the Christian story but the story just of an adjunct, the Cross, is brought to bear in unvarying metonymy on a variety of stories wherein its only point is its progressive impingement across a long span of time. It should be noted so far as the battles are concerned, that underlying a sameness of perspectival control, each of these battle scenes marks differences strongly within the panel in question; and Piero handles these differences differently from panel to panel, from the open and measured Constantine panel to the crowded Heraclius-Chosroes panel.

In any case, if we profess, as we do, seriously to admire this art beyond its representational virtuosity or formal organization, we must make considerable transpositions to retain it while rejecting (though allowing for) its central matrix of reference. Of course we must do the same for the Iliad and even the Odyssey.[44] What is called for is something much more complex than a "suspension of disbelief," and, without undertaking the task of reconstructing the conditions of a psychology and phenomenology of hermeneutics, we can notice, without accounting fully for it, that our admiration of an

Assyrian frieze can indeed coexist with our rejection of an Assyrian war code.[45] Of course this is, again, an obvious point, but its bearing on our artistic assimilation is not so obvious. The artist, the anonymous Sumerian sculptor or Phidias, or Piero, has managed to shape his way through to an apprehension that enlists our bodies in the sort of coordinated validation and exaltation of the world that the systematic studies of Merleau-Ponty and Lacan have dimensionalized.[46] To explain how the artist has done so calls for further analysis, both philosophical and art critical, but some such process must be called into play for us to understand what happens when the ethos of battle is both evoked and nullified in our aesthetic perceptions.

In Renaissance literature, as it developed after the time of Piero, the assumption prevailed that collective prowess in battle was a noble subject. As in legions of medieval epics, battle was allowed to dominate the narrative epics of both Ariosto and Tasso, through the idealization of a religious combat, and Spenser in *The Faerie Queene* introduced the further idealization of combatants who were themselves composite allegorical entities. For later painters scenes from Tasso and Ariosto were popular, allowing for the subsumption and reflection of battle into a religious purpose vaguely connected to the Crusades, and allowing as well for the suggestions of exoticism and of the romance under difficulty that figure in these long poems. Shakespeare, of course, built battle and interpretations of battle in relation to other human activities into nearly all his tragedies. It is hard to divorce *Henry V* from a jingoism unacceptable to us. Milton, who revised his epic intention away from battle by subsituting Adam as a subject for King Arthur, classified battle unequivocally under the Death that takes over the world after origi-

nal sin. Shown scenes of war by the archangel Michael, "Adam was all in tears." "Others to a city strong/Lay Siege, encampt; by Battery, Scale, and Mine,/Assaulting; others from the wall defend/ With Dart and Jav'lin, Stones and sulphurous Fire;/On each hand slaughter and gigantic deeds" (*Paradise Lost*, XI, 655-659). Milton's only representations of war are of War in Heaven, where the infernal hosts are explicitly compared as of the same kind, though as greater to lesser, with famous human battles, "For never since created man,/Met such imbodied force, as nam'd with these/Could merit more than that small infantry/Warr'd on by Cranes: though all the Giant brood/Of Phlegra with th'Heroic Race were join'd/That fought at Thebes and Ilium, on each side/Mixt with auxiliar Gods; and what resounds/In Fable or Romance of Uther's Son/Begirt with British and Armoric Knights;/And all who since, Baptiz'd or Infidel/ Jousted in Aspramont or Montalban,/Damasco, or Marocco, or Tre- bisond,/Or whom Biserta sent from Afric shore/When Charlemain with all his Peerage fell/by Fontarrabia" (I, 573-587).

Such transpositions take us far beyond Piero. The city- states of the Italian Renaissance were for centuries as often as not at war. They enlisted the professional skills of painters not only to celebrate such combats as Uccello's *Niccolo Mauruzi da Tolentino at the Battle of San Romano* [**Fig. 8**] or Simone Martini's in the Palazzo Pubblico of Siena, to say nothing of the elaborate murals planned but not executed for the Palazzo della Signoria in Florence by Leonardo and Michelangelo. Leonardo and Michelangelo were enlisted to help with planning fortifications and engines of war. As today, the applied mathematician—who in Renaissance Italy may have been a painter, as Paolo, Piero and Leonardo were—was summoned to bring his skills to bear on the arts of war. As a painter Piero

executed several interrelated commissions for one of the most savage combatants of his day, Sigismundo della Malatesta; and another such, Federico da Montefeltro, is shown, more prominently than many another donor, kneeling in full armor in the foreground of the Brera *Madonna.*

Very often scenes of battle were integrated, as in this True Cross cycle, with scenes of peace, and with religious scenes, as much later in the magnificent halls of Venice's Ducal Palace. So in the Palazzo Pubblico of Siena, Simone Martini's imposing equestrian fresco of a famous commander dominant over a distant cityscape stands in the midst of religious scenes, panoramas, and portraits of legendary heroes, while other rooms are devoted, respectively, to allegories of government, and to scenes of battle.

The Crusades, and the conception of the Church Militant, bring the age-old military ethos into the purview of the Church and give a self-righteous legitimacy—surely for the Renaissance, but surely not for the idealized modern viewer—to the two battle scenes Piero includes in his True Cross frescoes. Indeed, the notion of the *Miles Christi,* the soldier of Christ, goes back at least to the time of Constantine, who notably exemplifies it, and military orders were formed in the twelfth century to further the Crusades. The continuation of the emphasis and tradition carries through Piero's time to the founding of the Jesuits a century later. *Regimini militantis Ecclesiae,* "On a Regimen for the Militant Church," is the title of Pope Paul the Third's founding document for that order in 1540.

Eve Borsook sees Piero's frescoes in the context of propaganda for a specific Crusade, and possibly also as propaganda for a vicarious pilgrimage to the Holy Land.[47] Of course the notions of pilgrimage and crusade, while distinct, were mutually reinforcing.

But such notions, even if they correctly contextualize the impulse for Piero's frescoes, are far too simple to cover their effect, in space and time and in the achieved combination of the two. Even for these battle frescoes, Piero draws on the tradition but complicates it, deflects it, mutes it, and qualifies it (not necessarily in the direction of an implied pacifism), as we can see by comparing his *Defeat of Chosroes* with the comparable frame of a twelfth century Byzantine representation of the *Defeat of Maxentius* on the Stavelot Reliquary, or even with Agnolo Gaddi's representation [**Fig. 4**]. The qualification is drawn away more simply, so to speak, in *The Victory of Constantine* [**Plate 1**], through the central river that drowns the invisible Maxentius at the Ponte Milvio. This "absent" bridge, the Milvian, in Piero's arrangement of his panels, stands just below the bridge that is impassable for Sheba because it is made of the wood of the True Cross. In Constantine's Christian triumph the placidity of the river, drowning the pagan ruler, flows between the two camps. At the precise center of this picture the blue river winds away, mirroring the upright pattern of the erect dark tree trunks that lead back to the distant light houses standing either side of the stream, which in the foreground is framed by the arrested white horse of Constantine to the right side, and to the left side by the all but full length of the brown horse powerfully pulling its hind quarters up out of the river as its side-facing rider moves measuredly away in defeat. Banners and lances and riders on both sides are orderly under the vast blue sky that begins at a point less than halfway up the height of the panel.

The overall repose and peace of this scene are remarkable, given the general iconography of battle scenes. One could contrast this one with countless others, and significantly with a much later

painting of this same battle (1655) by Claude Lorrain, whose rendering provides the violent clash one might expect from a battle at or upon a bridge, and even from a painter like Claude whose overall work is so placid that some very large proportion of it bears the term "pastoral" in the title. In this fantasy representation **[Fig. 14]**, where the Ponte Milvio is placed at the seacoast, Claude's usual placidity does spread through the painting, except for the busy pugnacity of the segment that shows his encounter, where the combatants are so forcefully confronted that some are thrown headlong from the bridge. The battle scene, in both of Claude's very similar renderings,[48] is dwarfed by a woman driving a flock of cattle in the foreground, and by the peacefulness of the vast scene beyond. But it remains violent, in a version of what could be called, from Auden's poem on that painting, the Brueghel's *Icarus* motif. Yet in the battle segment of Claude's painting the violence is intense. Nothing like this turmoil disturbs the all-but visionary proportionateness of Piero's version of Constantine's battle.

In Raphael's Stanze in the Vatican the Battle of Constantine is presented as a classical "high action" struggle, filling the four walls of an entire room. In the historical conception that Dante and others record, Constantine's victory at the Ponte Milvio was crucial for his winning the empire, and so for Christianising Rome. His acquisition of the True Cross stands as a metonymy of that larger central process, a sort of angle on his domination, shown by the Arch of Constantine, his founding of the Basilica of St. Peter's, and in many other ways. Piero modifies all this domination. The serenity of Constantine's battle would be out of place, did it not transform into a spatial presentation a sense of religious rightness and inevitability, of power invested with a prophetic piety, importing into the

battle itself the image of this first Christian emperor, as more
embracingly in the panel *The Dream of Constantine*.

Still, in Piero's overall sequence, as against the contrasts of
Constantine's orderly battle with the crowded, "busy" battle of Her-
aclius, there is a preponderating tendency to accord similar repre-
sentations to scenes iconographically similar; Heraclius, like Con-
stantine earlier, is a Christian Byzantine emperor saving the True
Cross from pagan might. Yet in *The Defeat of Chosroes* [Plate 4] the
placid river has disappeared. Now a sphere of wounding abuts a
sphere of confrontation, flanked by the ordered desolation of an old
man who looks almost the type of the God the Father of *The Annun-
ciation* on the wall at the angle. The aged Chosroes is bowed as he
awaits beheading beneath his parody of the Throne of Heaven. Here
the True Cross, which is the linking subject of these panels, is to be
seen, set inconspicuously but exaltedly in place as the sign of God
the Son. For Chosroes to have succeeded in carrying out his her-
etical version of the Trinity would have been a wrenching of its true
function. Still, from Piero's point of view the Cross is the real arti-
cle. Chosroes, if he had managed to mount the throne, would have
carried off the blasphemy of a man posing as God the Father,
between the Cross of the Son and the crow we see mocking the Holy
Ghost. These still would not have been signs coordinate in function:
the actual True Cross, the living but aged and mortal Chosroes, and
the live black cock. But together they do signal a last gasp of the
pagan deflection of the Cross. Indeed the blasphemous self-
apotheosization of Chosroes exaggerates and distorts the tradition,
oriental but also Roman, of the king who claims for himself divine
attributes. Divorced from these in the space of this panel, Chosroes
holds bowed in a humbled posture a head hoary with the mortality

he has wanted to belie. The power undoing him struggles in mighty clash beside him, and the peace to which he does not have access floods the withdrawal in his face.

After the victorious Heraclius exalts the Cross in the final panel, it will stay exalted. *The Victory of Constantine* [**Plate 1**] has no corresponding segment, but its four flags match the four prominent ones in *The Defeat of Chosroes* [**Plate 4**]. Signification, still sub-historic as it is sub-typological, takes over in these battles from the immemorial iconography, Greek, Roman, Byzantine or Italian, of Battle. Religious jingoism is certainly not eschewed here, but neither is it exalted; rather, it is held in place by the deep subjection to time implied in the long sequence of events from panel to panel, and in the elaboration of meditative constituents that each panel bodies forth. The relative placidity of Piero's panel of Constantine at the Ponte Milvio, as I have been saying, contrasts with the visual portrayal of melée which is nearly constant for battle scenes throughout this long and varied tradition.

For the culminating battle against Chosroes, the scene is presented in "bas-relief and against the laws of perspective"—a flattening that for the great perspectivist must be deliberate, and so can be taken as pointing at further schematization.[49] Piero's handling of space is at work modifying the theme in this panel, as further in the juxtaposition of it within this whole cycle of frescoes. Beyond the typical battle, the scene tends to resolve into a series of individual duels, but simultaneously to be pulled back into the general melée, which seems to be played out by the time the eye has got to the furthest segment on the right, to the humbled, kneeling, aged Chosroes. He is strangely peaceful before his beheading beneath his empty throne, especially by contrast with the strenuous

fullness of the battle and its several blood-lined neck incisions. Those incisions proleptically refer to his execution, while displacing it to a different slightly earlier time, one of course connected to it, since the defeat must precede the execution. And the incisions also displace such reference to a different space, that of the bloody battle on the larger right half of the panel. On the smaller left half of the large panel, Chosroes' neck is as yet untouched. The two most pronounced of these incisions, indeed, do line up with Chosroes, that of the figure kneeling under the Mongol soldier and that of the brown-uniformed figure almost prostrate beneath the white horse. They are in Chosroes' horizontal register, and they stand frontally close to the presented foreground, as he does. They are at the left center and right center. Chosroes is at the extreme right, while at the extreme left, and at a point so low in the horizontal register it lines up only with pools of blood, is the head of a man under another's topsyturvy legs lying in a pool of blood.[50]

Across this picture horizontally Piero gives us not just the several angles of Uccello's *Battle of San Romano* [**Fig. 8**] but a complex of ordered elements, set out in horizontal registers, for which the opposition Eastern-Western or pagan-Christian, while accurate as a résumé, is too simple as an account.

Indeed, it is arresting to compare Paolo's three interrelated secular panels of the Battle at San Romano with Piero's battle panels, especially in the light of the practice of both artists' interest in both formulating and modulating perspective, and also in view of the fact that very likely the works are nearly contemporaneous. In Paolo's London panel [**Fig. 8**], we are shown a wide and mountainously uneven space that has nevertheless been divided to the inch, as the layout of these fields shows, according to Brunelleschi's and

Alberti's principle of *costruzione legittima.*[51] And it is a space that is contested, every quarter of the background given over to anecdotes of contestation. It is a dangerous space; here the battle is just getting under way. The peaceful life it supersedes is imaged in the fully fruited orange trees immediately behind and above the commander. The very fruit suggests apples of paradise in a common iconography, "like golden lamps in the green night" (to quote Andrew Marvell). These trees are cut visually by the crowded, angled lances, here painted a near orange and a kindred blonde color. Here the fruit cannot be plucked; there is neither time nor opportunity; it is subject to destruction.

The lances dominate just the left of the picture, counterbalancing the right, where they are not slanted upward but tilted at the full horizontal of combat. In the Paris and Florence episodes, the slanted lances are distributed across both halves of the picture in each case. In the Florence episode, through the central, divided fields, animals are leaping every which way in fright, cornered at the center, as are the animals in Paolo's *The Hunt* at Oxford. We have learned from ethologists that men and animals are alike in their territoriality. They are hypersensitive to the demarcation of the space they control, and the aestheticizing enclosedness of Paolo's conception is indicated by the visualization of the territorial threat that the animals show and figure here. The domination of man crowds out their space, when he arms to contest it with other men, as one horizontal brown lance cuts through the center foreground to unhorse and slay the key Sienese contestant.

In the further episode of this battle, the Louvre panel, armor, massed horses, lances, plumes and banners dominate the entire picture, and the lances, almost in the image of a spread clock

(And Paolo had designed and painted the clock face of the Duomo in Florence) rise from horizontal at the left to a mass of verticals at the center, just beginning at the right to tilt the other way outward. And as with Piero, the varied perspectives[52] reinforce the spatial complexity, throwing the interpretation of what so much aestheticization amounts to back to the arrested viewer. But Piero offers a far more complex modification. Where Paolo displays his horses and riders in a checkering of contrasted segments and colors, Piero offers much more muted gradations of color and figuration with each panel, while at the same time positing the relation of each whole battle with his other panels.

Starting at the top of *The Defeat of Chosroes,* this panel's first register consists of blue sky, punctuated by white clouds small enough for at least visual association with the other punctuating elements—with banners, lances, the high open-latticed arch over the throne of the strangely dignified Chosroes, and finally the slender True Cross, the narrow cock and the narrow candelabrum frame. In the next register, the broadest one, the massed combatants and thronged horses dominate, but they are qualified, as the space slides into the later time of the battle's aftermath, by the hushed ominous circle round the bowed, condemned, Chosroes. The lowest register, which overlaps like the others, consists of a brownish-green ground—the only considerable, but thin, monochrome stretch to correspond to the cloud-striated blue sky. The ground, as the sky with clouds, is streaked by as many pools of blood, where the falling and fallen are caught in a line with hooves, feet—and again with the kneeling Chosroes.

Piero's handling, by mounting the complexity of interrelated references in his frescoes, and also in these single battle frescoes

taken separately and together, moves beyond, and moves the view-
er beyond, the simple participation in the visual contemplation of
battle. He subsumes that ethos, gives it the (itself traditional) appli-
cation to religious justification—a justification felt at the time, by
some combatants, to bear on any battle at all, when the Pope him-
self might be fighting on one side and still the other side might feel
that he was religiously as well as politically in the wrong. Guelph
and Ghibelline are only particular, and shifting, terms for congeries
of such attitudes that consistently mix religion and politics through
these centuries.

Here the Cross is unsuccessfully placed at the left of Chos-
roes' throne as the cock at the right parodies the dove of Holy Spir-
it. The Cross is also visually diminished by being shown in half-
profile and at a perspective distance. As a key to the scene it is
singularly, and for this sequence typically, entangled in all the other
elements, visual and iconographic. These are arranged in a loose-
ness so subject to anecdote that the organization of the picture
seems to supersede it but must finally be taken as resuming it. The
spatial handling is at work manipulating and qualifying the stark
military theme, so as to open in this panel its difference between
the crowding on the left and the relative emptiness on the right,
aligning it, as with the limpidity of *The Victory of Constantine*, into
the overall contemplative organization of the other panels.

In the horizontal register of the banners, the thinnest ban-
ner, the one unfurled behind Chosroes' throne, is of the stars he
claimed to command. The color of its field, as Battisti notes, is
rhymed to his mantle and to the cushion of his throne.

The four horses at the center, remarked on by Vasari, come
at each other head-on. Two white ones angled against a black and

brown, seem to arrest the battle into a stasis, the more that none of the wounded men stands inside their thronged, open square, and the two most prominent victims are just outside, one of them separated by the raised shield of the Mongol warrior, and the other below, just in front of the foremost rearing white horse. The Mongol warrior, a figure visually central and thematically only episodic, is singled out by the prominence of his white conical hat, even more sharply than is the blocked trumpeter in the tall white toque behind him. The Mongol's white hat stands alone in the register below all the other hats. Already in Herodotus, groups we may identify as Mongol are at the extreme edge of the Persian Empire. Piero has brought just one such Mongol almost to the center of his battle, in a situation of momentous dominance, as though to suggest such variety and extent in the Empire that is going under to another that is also Eastern, but Christian.

In the upper register thin banners alternate with full ones and problematic banners with obscure ones. Above the blue, starred one is an open white one bearing the trace of a black man, his head banded, trailing from a circlet around and below his neck the vestige of a mantle terminating in green leaf-shapes; and below the black on this banner is an identical smaller black head on a coat of arms. This complex banner is divided by a furled green banner from an open white cross on a red field, beside another of a dun lion on a red field (both presumably Christian) overlapping onto a larger black eagle, wings spread and mouth open, on a yellow field. At the left, on a green field, the banner of a large swan.

It is very hard visually to trace these banners to the sources below them in the next register down. This register itself is dominated by headgear—a brown open helmet, a darker visored helmet,

a green open helmet, a visored steel helmet, the tall trapezoidal white toque on a trumpeter, two more vizored steel helmets, a man in a simple white headband, a bareheaded man, two more helmets, another bare head, another visor, a golden cap, a purple, a brown, a green, a brown, a violet, a blue, a brown, and a green helmet all but lined up against the various directions of their wearers. The most spectacular helmet is a rich red helmet much-decorated in white furls and a pine cone, tied under the chin of the man receiving the most spectacular knife-wound to his jugular.

The crowding and variety of this register suddenly gives way to open space over Chosroes' throne. Below this, a circle of conquerors stands over the Chosroes whose bare head a simple coronet girds. They also have their heads covered variously: in a pearl-sewn geometric red helmet, a tonsure, a burnished brown cap, a red velvet cap, another blue one, a golden one, and a red one rising to a puffed crown. All this headgear sometimes matches, sometimes complements, the dress of the wearer. The conical white cap of the Mongol warrior, again, is singled out because it is out of line with all this.

The next register down, the massing and grouping men and horses furnish the widest horizontal band, and the one central to the battle, dominating the simple aftermath of its sequel to the right, the moment before the beheading of Chosroes, a moment so quiet that its summary violence is indicated only obliquely as an imminent analogue and logical sequel to the military deaths shown in the battle dominating the panel.

This battle obliquely corresponds to the obliquity of *The Victory of Constantine*, where Maxentius is the corresponding loser, but his drowning in the Tiber at the Ponte Milvio is only suggested, and

also imaginatively countered, by the calm, fully mirroring stream winding through the center of that panel, the banners of eagle and swan to the Christian left, green dragon and black Saracen to the right, upraised and separated, as are the horses, in this earlier battle.

Both the obliquity and the proportionateness of these two battles, and the very differences between them, testify to Piero's handling of a space that is conceptualized (even, for him, mathematicized) in the very act of setting it out on canvas. Space, to begin with, as Kant and recent anthropologists have asserted, is a category so fundamental as to be arguably primary. We locate ourselves in and through space, and our understandings begin by related locations in space, as does the very possibility of our survival. Military actions bring the underlying tightness of human space to a head: the argument that begins them is perforce an argument about space, and representations of battle tend to be crowded for obvious reasons. Now *The Victory of Constantine* offers a counter-space by allowing for openness beside its limpid stream; and *The Defeat of Chosroes* does so differently at the right side of the painting, where a large emptiness is portrayed, the theological emptiness left unfilled by the failure of the bowed Chosroes to substitute himself for the Trinity.

Thus is a dialectic set up between the viewer, located in space as he allows these various spatial representations to reorganize time, and the concentrated, pointed significations of these single scenes. We are already in a domain of space-manipulation that Michael Fried has spelled out for the eighteenth and nineteenth centuries, and in some cases with respect to "history" paintings related to military action. Fried has worked out a dialectic that can present

itself in a painting for the relations among painter, beholder, and the enlistment or withdrawal of its spaces towards both. While he isolates the development in the theatricality (and anti-theatricality), as well as in the absorption, of French painters in the climate of Diderot and beyond, the point can be generalized. A comparable dialectic is at work in Velazquez's *Las Meninas* and perhaps also in other works like *Las Hilanderas*. It helps intensify the late paintings of Goya in which flying monsters are close to the picture plane but distant from what they are flying above. More appositely with respect to history painting, Fried shows that in David's *Intervention of the Sabine Women* "a moment of sorts," is "in a general détente." It exhibits "a general dedramatization of the action."[53] A sort of passivity and impassivity, he argues, obtains in David's *Leonidas at Thermopylae*. In immediately subsequent works glorifying Napoleon, Gros' *The Plague at Jaffa* and *The Battle at Eylau*, the action is pre-accepted as something "already wholly theatrical"—a characterization that will hold as well for *The Defeat of Chosroes* as it merges the two moments of heightened pitched battle and imminent execution of the blasphemous pagan emperor on the left. In this light, again, *The Victory of Constantine* assimilates easily to the exemplary momentariness of its own particular temporal dimension in the vast temporal array of the series. But the structuring of Piero, if we compare it with Gros, spatializes the narrative, even as it focusses not just on the moment, as Gros and the usual painter of battle scenes do, but on two moments, and their differing spaces, in a sequence of some three or more millennia from Adam just to this Heraclius.

Piero's manipulations of the battle scene into a larger aesthetic conception, however, can be measured by another imposing

painting from a different, somewhat later tradition, *The Battle of Alexander* by Albrecht Altdorfer (about 1530) **[Plate 8]**. This is a large, secular painting, removed from Piero's religious context, commissioned to decorate the Residence of Duke Wilhelm IV. Altdorfer had already participated fifteen years or so earlier in the huge triumphal gate for the Emperor Maximilian, an ordered series of woodcuts into a composition 3.4 by 2.9 meters, printed entirely on paper, as a strange and emphatic substitute for the more normal marble. The central gate of this giant work is composed of coats-of-arms, and the lateral scenes which Altdorfer contributed (along with Dürer and others) were drawn from the life of the Emperor, setting his prowess at tourneys and his role in mounting artillery alongside his activities as builder, linguist, and hunter. Altdorfer executed another even larger series, watercolor on parchment, which unrolled an ordered panorama of Maximilian's various victories, a work that for all its size stayed within celebratory conventions that *The Battle of Alexander* expands.

It does so notably by providing a vast landscape to extend and also dominate the already extensive battle. Altdorfer was one of the earliest Renaissance artists to devote works exclusively to the representation of landscape. The combination of landscape and battle, in the upper half of the painting, and also the representation of the combatants in a smaller, more diminutive scale than in Italian painting, was already part of the convention in which Altdorfer was working, to be observed in the other battle paintings among those commissioned for the Duke's Residence: Jörg Breu's *Scipio's Victory over Hannibal at Zama*, Hans Burgkmair's *Victory of Hannibal over the Romans at Cannae*, Melchior Feselen's *Julius Caesar Besieges Alesia*, along with Ludwig Refinger's *Horace Cocles Defends the*

Bridge over the Tiber and *Titus Manlius Torquatus Defeats a Gaul in Personal Combat.*[54] All these works set their diminutive, crowding figures into a fairly simple order with a smaller landscape vertically above them. In Altdorfer's great work, however, the enormously expanding armies are arranged on two levels, a plateau and an area below them, and spread in a large S-curve, the tents, banners, and lances pointing in a skewed echo of their order. To the left in a nearer distance the S-curve continues steeply upward, winding through buildings built on crags and promontories. The entire right side, above the armies thronged in its lower third, is taken up with a still larger S-curve, beginning with a bay opening from a city that is distant enough so that its cathedral measures scarcely taller than Alexander and his troops in the upper foreground. The mighty mist-filled bay continues to a further distance. It gives in the continuing S-curve on a vast range of snow-covered alps, in a still more extreme distance, under a cloud-besting sun, waters and mountains all in a bluish white that is picked up in the banners of Darius at the near right across the painting's surface. Altdorfer at once imposes and dwarfs his armies, and the archetypal triumph of Alexander is both glorified and swallowed up in the cosmic reach of natural forces, in whose grip the masses of men are caught, as the relative smallness of their scale suggests.

Piero's own final panel, *The Exaltation of the True Cross* [**Fig. 12**], restablishes a religious order, as successive to *The Defeat of Chosroes*. In this panel a much larger white-streaked blue sky dominates the simpler open spaces of the embassy to Jerusalem. The tall white oriental toque of the trumpeter from *The Defeat of Chosroes* has here blossomed on the right into a doublet of itself. This hat is tipped in respect towards the Cross as its white stands

out against the red of the hugely turretted walls of Jerusalem
behind its wearer. He is the only close-up figure not kneeling of the
group poised to receive Heraclius across the green between them,
though an older man, whose white beard and features, recalling
those of Chosroes, are now truly benign, stands in measured per-
spective distantly behind him, green-cloaked, flat-capped and shod
in brown. Four of the six men approaching upright on the left wear
tall headgear, a man in profile in a rounded brown-banded green
cap, a man in a red toque whose white-robed back is to us, another
of multicolored dress in a green toque, three-quarter face. Two oth-
ers are in profile, one in a dark blue cap, one in a split cap of a light
violet to match his robe.

Heraclius, leading the Cross in front, has his head simply
banded in white, as variously do all those kneeling across from him
on the left. Here the ground is not crowded but simply open; there is
a sense of calming and opening, while the patterning of colors in the
prior Battle scene is now more subdued, though comparably geome-
tric in presentation. The sky runs more than two thirds the height
of the picture, punctuated by two tall flourishing green trees, by the
red towers, and by the light brown cross. This final panel, like the
Adam panels at the beginning of the whole series, is bordered by a
scrolling chain of stylized brown leaves and flowers in green circlets,
as though transposing the persistence of vegetation through trees
and wooden Cross into a still more omnipresent, circumambient
motif, subdued and now completely separated from narrative time
because it has become a permanent and domesticated accompani-
ment of a time so undifferentiated as to be both linear and circular.
Both of these patterns themselves are features of the framing deco-
ration, transcended by the centering on a Heraclius whose humble

posture, fixed as emblem rather than as anecdote, conveys a sub-
dued piety to the whole cycle it culminates.

VI

What, finally, is the status of the perceptions that have thus
been organized by Piero, and, as an inescapable corollary, of those
deductions from them, mine and those of others? By interpreting the
space in its interaction with the legend, I have tried to raise once
again the question of non-verbal communication in the form of how
it may incorporate signs analogous to verbal ones, and vice versa.
Intrications of the relation between sense and reference may extend
this question.[55] But such intrications cannot wholly solve the fusion
of discourse and figure, because they remain posterior to it, as the
painting inescapably and directly combines an act of representation
with an act of interpretation.

It should be remembered that, in contradistinction to the
Renaissance artist, the modern painter characteristically turns out
his work in a relatively short period of intense activity, even when
he builds it up by considerable studies, or with sometimes more
than a hundred sittings like Cézanne, or with constant erasures and
minor adjustments like Matisse. Piero, however, almost surely
worked on his cycle over a long time, as did many Renaissance art-
ists before him, Giotto and Duccio and Masaccio among them—and
as did many artists of his time and later, from the Ghiberti who
spent years at two different periods on the stages of his bronze
doors to the Michelangelo who did the same for the stages of the
Sistine Chapel. So Piero would seem to have dwelt for a very long

time on the calculation and execution of this cycle—perhaps longer than Milton spent on the execution of *Paradise Lost*, perhaps even a longer time than Tolstoi spent on *War and Peace*.[56] The long time he was at work must have involved what later theorists called "disegno interno," an internal and mental act of gradually figuring the picture in many of its aspects.[57] Such a long period of activity argues for something amounting to a prolonged meditation over significances, as does the circumstance that Piero would seem to have wholly given the last fifteen years or so of his life over to high-level mathematical speculations. It seems likely that those same combinatory powers of mind would also have been applied to his paintings, and not just to the formal calculations about perspective in them. In all this, the question of connection between verbal and nonverbal remains primary, and is posed by Piero's prolonged and elaborate act.

His attention to blocking in the True Cross sequence, again, is strongly abetted by its almost matte colors, if one can venture such specifications on the basis of what remains to us from the fading and alteration of time. Their low intensities are remarkable in the light of the rich array of color effects that Piero is here eschewing, and one thinks of the delicate irisings in the earlier *Baptism*, the deep richness of the blues in the later *Nativity*, and the intense gamut of gradations in the ordered saturation of the Brera *Madonna*. In the Arezzo sequence he lacks the density of Giotto and Sassetta, the richness of Fra Angelico, the later shadowy range of Titian. The solid but unemphatic colors, as they are now and as we can construe them to have been, reinforce the presence of these bodies by evening them into the scenes they occupy with their large frontality. The austerity and fullness that Adrian Stokes calls "Quattro Cento" are here assumed and made to bear a larger set of

articulations, equivalent to themselves because they have not entered another system, the narrative sending us back to the visual, and vice versa. Our immersive and participative apprehension of Constantine and Solomon, Sheba and the Virgin, still retains something of austerity. What in another context Stokes calls the "good breast" evoked by a painting is provided by this series, but it does not stop there.[58] The strange, abundant, exhausted breast of the aged Eve itself elides into the scene parcelled out before her, and Sheba, whether kneeling or standing, cannot be distracted into the erotic anecdote or mere bodily presence or exoticism that hovers over the legend of her connection to Solomon. Here that connection is itself elided into another, a connection to a future directly involving neither of them, since Solomon, by electing to bury the wood for its threat to the Jews, removes himself from the typological sequence with Christ that in another context would be his.

The visible flesh of these persons, unrounded and undelectated by comparison with the flesh in the *Baptism of Christ* [**Fig. 7**], shades into the invisible sense of the body that Merleau-Ponty declares to underlie our perceptions.[59] This *chair* is an achieved, idealized one that moves all these participants into the rapt, processive look of the dreamer, even those who are caught in the heat of battle in the Chosroes panel. As again Roberto Longhi says, "It appears to us, finally, that one of the secrets of this art is that it confers even on the believed intervals among the forms a positive value of new plenitude."[60]

And in fact there is an invisibility to the narrative core of almost all these panels, something that is not there, where in a normal iconographic presentation what you see is what you get. The Crucifixion, the Virgin and Child, the Nativity, the Adoration, the Resurrection—these conventional scenes, and others, show their

subject. But Adam dies invisibly, and we do not see Seth get the seeds, and when he plants their branch in Adam's mouth we do not see the growth of the shoots, even though there is a full-grown, splendid tree standing emblematically in the background. Something in the mind of the Queen of Sheba makes her kneel, and what exactly is being communicated as the panel continues between her and Solomon? There is nothing that finds visible representation, or even expressive analogy, in this rich panel, though it may be assumed she is explaining to him another, contradictory property of the wood of which they have stood in awe. But their presence before our eyes is a merely ceremonial one. Below them Constantine is not exactly winning or fighting the battle, nor is Maxentius exactly drowning. The placid stream beyond the horses in its serpentine, mirroring course draws the hostility out of the confrontation, as the colors of the horses, in their blocked harmonies, return them to the invisible order far more than do the horses of Uccello, which are thronging into battle in a participative presentation. *The Annunciation*, unlike other parts of the Christian story, takes place by definition invisibly, and *The Dream of Constantine* takes place in its lit visual surround, with no indication of what the message is beyond what we know from the legend. Chosroes awaits beheading, but he is not beheaded before us, and the exalted, prominent throne on which he was proudly to sit stands empty under its large canopy in the middle of the emblems of large black cock and the banners of black eagle and black man, themselves emblematic of the heresy that is going under, arrested in time as the Cross, here barely visible before these discordant visible presences, is not going under—though the distinction between the victorious and the defeated among these emblems is not made visible.

All these secrets play us back into the enigmatic presences that the figures make the narrative block out because blocked from connection doubly. They are blocked from each other, except by the various rich structures of temporal sequence and thematic congruence that can be attributed to them; and they are blocked from the very moment of the story that they evoke but do not fully illustrate.

Bernard Berenson says Piero is "opposed to the manifestation of feeling, and ready to go to any length to avoid it."[61] Is this really true? I think, rather, we should try to see the diffuseness, the "spread" of feeling in Piero, not as an absence of feeling but as an evening, and consequent intensification, of feeling, achieved through these very blockings. If, as Berenson goes on, (5) "in his architecture ... [is] something like lyrical feeling." But is this "lyrical feeling"? It is certainly very different from what Berenson compares it to, Uffizi portraits "conceived as if they were objects" (4), or the comparable expressionlessness in Egypt, Greece, and Assyria; in medieval church sculpture, and, later, in Ingres, opposing the "mystical" to the "theatrical" (15). Indeed, there is in Piero a "synthesis ... between Florentine ... perspective and space and Netherlandish ... light and natural phenomena," something that can hold its ground for the strong hermeneutic, and even generic, uses to which I am trying to put it.[62]

Michael Baxandall[63] stresses the applicability to this painting generally of the contemporary terms of Landino. Especially applicable to Piero would be a different handling of the *relievo* for which Baxandall praises Masaccio, equating it to the *prominentia* that Piero surely attains through his closeup, flat view, as Andrea del Castagno differently does, though in Piero's case without the differentiations that result in the "tactile qualities" which for Masaccio

Baxendall calls equivalent (122). Piero more than others is surely *puro sanza ornato*, and also applicable to him would be *prospectivo, varietà, composizione*, and the *scorci* or foreshortening that are more remarkable, because arresting, not only in Castagno but also in Mantegna; the foreshortening, through proportionality (a way of handling perspective) attains a serenity in Piero foreign to these artists, a serenity that sheds its evenness across the many panels and the vast time span of the Legend of the True Cross.

Piero in these works, has struck a marvelous and unique balance between the alternately focussed and deployed temporal moments of the legend and the three elements he singles out as constituents of the space of a painting:

> La pictura contiene in sè tre parti principali, quali diciamo essere disegno, commensuratio et colorare. Desegno intendiamo essere profili et contorni che nella cosa se contene. Commensuratio diciamo essere essi profili et contorni proportionalmente posti nel luoghi loro. Colorare intendiamo dare i colori comme nelle cose se dimostrano, chiari et uscuri secondo che i lumi li devariano. De le quali tre parti intendono tractare solo de la commensuratione, mescolandoci qualche parte de desegno, perciò che senza non se po dimonstrare in opera essa prospectiva.

> Painting consists of three principal parts, which we name drawing, measurement, and coloring. By drawing we mean profiles and outlines which contain the objects. By measurement we mean the profiles and outlines placed proportionately in their places. By

coloring we how colors show themselves on the
objects: light or dark, changing according to the light.
Of these three parts I intend to consider only meas-
urement, which we call perspective, mixing in some
parts of drawing because without this perspective
cannot be employed practically.[64]

Piero's seeming contradiction, of saying that he will deal
only with *commensuratio,* the second of his three subjects and then
immediately declaring that he will mix in the first, *desegno,* indi-
cates the elaborateness, and the flexibility, of the intrication of the
two, a flexibility he will put to good use by leaning almost exclusive-
ly on *commensuratio* in this series, and by going light on the more
normal perspective, either geometrical or natural. To begin with,
desegno and color are traditional terms, and Piero has added *com-
mensuratio* to them, considerably altering the *composizione* of Alber-
ti. "*Commensurazione's* reference can be taken to a general
mathematics-based alertness in the total arrangement of a picture,
in which what we call proportion and perspective are keenly felt as
interdependent and interlocking."[65]

But in these works the picture plane has been made to pre-
dominate over perspectival vanishing points, while the latter have
been allowed a subordinate role, by comparison with Piero's other
works, as an incorporation of the "primitive" near-two-
dimensionality to a level of subtlety that refers the viewer back,
again, to the invisibility of the narrative core around which these
proportions are organized. So, for example, in *The Queen of Sheba
Adores the Sacred Wood* [Plate 2], the Queen kneels absolutely at
the level of the wood, and four of her six attendants are virtually on
a plane with her. The other two, however, are slightly distanced.

Between them and the attendant horsemen at the left is another fig-
ure, a man in a conical cap with nearly white skin and negroid fea-
tures, whom we cannot firmly identify as either dwarflike (which he
probably is) or much more distanced, so carefully have the vanish-
ing points *not* been allowed their firm plotting. And at the very
beginning of the left side, the head of the black horse is set above
the rump of the white one and beside the obscured eyes and ears of
the grey one and the profile body of the brown one that they have
the illusion of a parallel frontality of presentation whether from
front, side, or rear—when in fact, of course, the other two stand
behind the white horse.

The two large trees that proportionally divide this scene,
since their trunks are fully blocked by the other figures, seem some-
what to canopy them rather than to stand behind them, their calcu-
lable position in the represented space. The frontality of figures
inside the pillars of Solomon's palace, in the Encounter that contin-
ues this panel to the right **[Plate 3]**, is even more pronounced. The
thirteen (or fourteen) figures are lined up in their flattened circle as
though to press them almost onto a single plane, while at the same
time one stands behind another as both stand behind the first and
fourth, and there are perspectival overlappings that are reinforced
by the illusion that this room is much narrower than it has to be
thought of. The pillars and the beams of the ceiling are measured to
shrink this space, which the very presence of pillars and beams
tends to expand, as does the very conception of a royal audience
hall.

The comparable pair of continuous panels on the left wall,
the *Testing of the Cross* and *The Discovery of the Cross* **[Fig. 9]**, like-
wise lines up a number of figures around, but visually along, two

crosses, against fields that seem too distant at the right, and a dominant town that seems too close at the upper right. Still closer is the simple geometricized facade of the Church at the right before the kneeling group of Helena and her attendants and the three men at the extreme right standing to watch them, behind whom the walls and towers of the city give the illusion of being compressed into near two-dimensionality.

In general, Piero's painting offers not just an application of his own perspectival theories but a complex relation between two-dimensional and three-dimensional space, those profoundly different approaches in which, at the remote paleolithic beginning the two-dimensional was the more complex, as requiring a constructive projection.

The matte colors allow for cross-contrasts of all sorts, an elaborate effect: as in the somewhat conventional, but arresting, diapered pattern behind the Virgin of the *Annunciation*, which for me is reminiscent of the polychrome striped blanket at the center of Giotto's *Birth of the Virgin*, or of the patternings behind the throne of Virgin and Child, and again behind the Virgin and Christ, in Duccio's Buckingham Palace triptych. Piero in this series has eschewed the bright colors, the richnesses and densities just hinted at in Solomon's robe, to which he has such spectacular recourse in his *St. Julian*, in the Williamstown and Urbino *Madonnas*, in the *Nativity* and the *Baptism*.[66]

Piero's colors generally are sub-symbolic. He often matches related segments of the same color (brown/red) or repeats from block to block interrelated segments (as in the garments of the two blocks of the Queen of Sheba panel). As Battisti well says, stressing Piero's congruence with a palette recommended by Alberti (and following him in the avoidance of yellow):

Piero in the backgrounds avoids violent colors, which
are reserved in general for personages. Color does
not, however, create effects of differentiated planes,
or better, it creates them occasionally through an
emphasis on images of exceptional luminosity or
chromatic saturation. Piero on the other hand real-
izes rhythms that are extremely broken, also juxta-
posing pure hues (green, red and azure, violet and
orange), but maintaining all on the same plane and
so bringing it about that the contrasts accord in the
whole ... Further, his palette is singularly limited by
comparison for example with that of a Fra Angelico,
who would seem at first glance fairly close to him.
Above all, he lacks yellow, the most aggressive color,
and his effects of light are rarely obtained with alter-
nating timbres or with sharp alterations, but rather
by expedients of chiaroscuro.[67]

VII

In other works Piero modulates his handling of space and
color quite differently with reference to the senses of the work. The
small space of a cemetery chapel at Monterchi contained the *Madon-
na del Parto* [**Fig. 10**], the pregnant Virgin herself a kind of contra-
diction, or promise of resurrection, to the enclosure for the dead
from which her presence, pregnant belly first, thrusts forward. This
is itself a tremendously pregnant enlistment of the figure of the tho-
los, the round temple enclosing space, here a tomb, as a spatial echo

of the roundness of the pregnant body. The rounding of the Virgin's body is emphasized by her opening dress, and also by the rounding of the canopied pavilion whose curtains the two angels are holding open for her. The subdued russet of these curtains is echoed in their haloes, in the outer roof of the pavilion, and in the robe of the angel to the left, the shoes of the angel to the right. The blue of her own dress is off-echoed in the green robe of the right angel, the wings of the one on the left. In this simplest of Piero's palettes she stands against a light brown interior, nearly echoed in the coloring of her face and that of the angels.

Always Piero both mastered and manipulated space. He arrays a whole Christian history down the garment of his *St Augustine* in Lisbon, who has segmented icon-like scenes of the Passion embroidered in rectangles down the front lapels of the robe on both sides—Annunciation, Flight into Egypt, Crucifixion, Circumcision, Nativity, Transfiguration. Some of these are concealed, and their alternation between display and concealment through the unusual positioning along the front of a garment of scenes usually placed on the altar of a church finds a differing echo in the puzzling transparency of the staff of Augustine's episcopal crozier.

Around the central figure of the elaborate polyptych of the common subject, the *Madonna della Misericordia*, the figures under Mary's robe are turned *round*, when in the usual presentation of this iconography they are frontal.[68] The hooded man there, his eye piercing the black cover, shows in the background row not only his membership in a strange religious confraternity of the time but also his need for misericord, as do the powerful expressions of St. Sebastian and St. Francis, among the others. In this work scale does duty for perspective. The figures under the Virgin's mantle are tradition-

ally tiny; but, somewhat unusually, the saints are nearly as large as she.

The Brera *Madonna* [**Plate 5**] is set under an arch that is almost the same as the arch of Alberti's Sant'Andrea in Mantua.[69] Continuing the elaborate architectural reference of this work, there are in it no fewer than three enclosing spaces—the arch above the Virgin with its inset design, the huge shell enclosing the presumed ostrich egg, and the pilastered walls of the arch, filled in various polychrome marbles. The floor is of a marble that picks up colors from two of the marble panels. Her platform with its oriental rug is forward and further framed by the floor moulding with its common border. A further (fourth) enclosure is the semicircle, nearly 180 degrees, around the Virgin, a figure that recalls the spherical emphases on ocular perception in Piero's treatises. The figures surrounding her, five on either side, are symmetrical, but they break into odd and even with respect to the distribution on each side of three saints and two angels.

I leave out of the reckoning the presence, both central and asymmetrical, of the kneeling Federico da Montefeltro, visually a supernumerary here, while thematically a key to the whole. Montefeltro's lance rises between his mail shoes and the Virgin. The lance is parallel to her stand, and to the lines of the moulding. His asymmetry tends to identify him with the observer by placing him in a position half-incorporated into the symmetry by detail, but not his whole body. He has placed his mail shoes before the Virgin, directly under the Child. The Child is horizontal, a position that enables the reference to gravity incorporated in his dangling coral and large pearl neck ornament. The pearl rhymes with the egg, and with the lustrous knob of the Virgin's chair.

The angels are signified by jewels in their foreheads, as though to single out their order by ornament alone, rather than by position too, as in the "Baptism" and the "Nativity." Their wings are barely visible, as if in keeping with the airlessness of this enfolding enclosure, in which a sense of plenitude is reinforced by the saturation of the gradated colors.

In all this frontality, remarkable are the various directions in the eyes of the represented saints, as though they are easily finding spiritual isue from the physical enclosure. By contrast the angels look straight ahead.[70] Montefeltro looks straight at the Christ Child, who is asleep; and the Virgin's eyes are downcast.

The colors rhyme but do not match. There are many blues, reds, greens, olives—but nothing like the shiny bluish steel mail of Montefeltro. The white of the Virgin's hair net is picked up by half the painting, and concentrated in the suspended ostrich egg.[71]

In the *Nativity* [Plate 7], Piero welds his color to his manipulation of perspective by putting all the rich variety of the blue so precious in his time, its saturations and its lightnesses, in the foreground of the picture.[72] Here the blue is too pervasive for a specific symbolism, though a symbolism of connection to the Virgin is present as it concentrates the blue richly into the Virgin's train, into the infant's pallet, and with less saturation into the cloak of the Virgin. The gradation, which is also a gradation away from specific symbolism, continues in the variations of the robes of the five angels and continues into the pale even blue that fills the entire sky, as the cool color of the sky spreads through the painting the tonic color that clothes the Virgin and comforts the Infant. Saturation asserts its thematic strength as the brown of the seated Saint Joseph matches that of the Virgin's train and is separated from it

only by the pale red of his own cloak. That brown, in turn, gives a heavy tonic earth-color note for the browns across the picture, for the unfinished ground, the unfinished browns of the two men beside him, the vegetation, the ponderous, central ox, and, puzzlingly, the hair of the angels, as though in that attribute earth were fitted to heaven and spread with it.

The architecture, so prominent in the True Cross sequence and so dominant in the Brera *Madonna,* here asserts a distinct but only emblematic presence in the nearly two-dimensional but vast blue-grey stable linking all these figures as a backdrop. This flimsy structure is set back so far that all the figures appear to be out in the open air of nature, and the Infant, unusually, has his pallet spread on the uneven brown ground, where the Virgin also kneels. Simply and schematically a distant town is shown in the small space behind the stable-strut to the right, while to the left the distant hills and a winding river, nearly undifferentiated at that point of the picture's completion, extends in the somewhat larger space to the left of the stable wall.

Posture, too, is made to seem schematic by attaching to kinds of being as well as to groups. The Virgin alone is kneeling. The central Infant alone is lying. St. Joseph alone is seated, in the schematic profile Piero elsewhere uses for portraiture. The two men behind him are standing, one gesturing. But most prominently the nearly central angels stand as two of them play their huge instruments (so far lacking strings), which are as large as the head of the ox. All five are singing, and that the music is a choral music with some differentiations of execution is suggested by the different widths of opening for their mouths. As a group they dominate the picture, spreading across nearly half its width. This particular coor-

dination of openings and closures, both in their mouths and in the structure and colorings of the whole, makes the picture itself an analogue to their music. The Virgin does traditionally wear blue, but this is a blue of unearthly saturation. The sharply receding hills in the distant background are light brown and blurred green. But they are as though gathered up in the concert of the singing angels who dominate the picture, central subjects rather than the ornaments that the angel musicians generally are. Indeed, in the iconography of angel musicians, they are either massed in groups that may be taken as choral but are often not definitely so, or else they carry instruments that are usually more prominent than these. By opening wide the mouths of his angels, Piero has transposed the instrumentation to the bodies of his figures. The open mouths emphasize the sound that the silent depiction represents.[73]

In the *Baptism of Christ* [**Fig. 7**] colors are spread in a rich, wispy delicacy over the angels; in solid blocks on the distant oriental figures framed by the disrobing catechumen in the middle distance; and in firm earth tones over the bare spots and vegetation of the rolling hills behind Christ, a landscape handled in other ways too quite more structurally than the conventional landscapes of the time.[74] The orders of beings are indicated in the painting by perspectival discrimination, openly, firmly, and elaborately, Christ and John the Baptist occupying the nearest foreground beside the angels who stand in glad but unaroused converse slightly further forward to the right, while the catechumen, who may be taken as the single plenipotentiary of humankind, stands engaged behind them. Far in the distance, though contained in that frame, are the elderly figures in Oriental garb who suggest both wise men and Magi. Here the colors reinforce the senses distributed in the careful structuring of per-

spective. Exactly reversing the arrangement in his other most regular perspectival work, the *Flagellation,* Christ stands at the absolute center and foreground of the picture, a man who in this picture is the measure of all things because he is a God receiving the baptism men will be enjoined to receive.

In the *Flagellation* [**Plate 6**] conversing figures occupy the foreground and Christ is off to the right in a contained distance. Yet above the pillar to which he is bound, white on white, is perched a golden statue, as though to insist on the persistence of the ideal humanity here being flouted. The gold figure draws on types of Sol, Apollo, and Hercules; and, as Marilyn Lavin says, "Piero has given the statue attributes describing the pagan qualities that Christ himself embodied and superseded."[75] This statue is the representation of a representation, as against the Christ who is a representation of reality, a moment of reality superseded by some of what the statue stands for; and in the higher reality of this theology Christ, as a person of the Trinity, also governs the whole. The statue is ideal in being nude, and he carries the sword and the orb that symbolize the earthly power of which Christ is here being deprived but which he will ultimately inherit. The old order of empire and the new order of exalted humanism come together, but not in the easy fusion of any "Christian humanism." No Platonism can make room for the moment of the Flagellation. Indeed, the nude with sword and orb is a strange composite behind Christ, a present embodiment of a future nullifying the moment of degradation and pain in the subject at hand. The orb particularly touches on the iconography of the Pantocrator from which Christ is distanced at this moment but ultimately, as the viewer knows, to be reconciled. Such a reconciliation finds its echoes in the gold of the statue and the white of Christ's

body, as well as in the whites and off-whites that, again strangely for a Flagellation, dominate this half of the panel—the Palazzo door jambs, the door opening behind the seated figure of authority which contains him in its alien blaze of white, the pillars, half the segments of the floor, and finally the roof, mostly in white, which itself takes up about a third of the picture plane.

As in *The Defeat of Chosroes*, the colors across *The Flagellation* are checkered in complications that suggest both violence (though more subdued) and a greater order to control the violence. Horizontal blood-red trapezoids with stripes of white, different from the vertical black segments of the court, are patterned precisely but irregularly. This blood or brick red is distinct from the red stripe on the hat of the right flagellant, the purple of the right outside figure, the dusky red of the facing blonde figure, his; bright red shoes and pinkish-red shirt. All these are shaded differently from the red feather of the seated judge, whose matching blue hat and trousers differ from the pale blue of the left officer or the gold-bordered blue of the older man on the outside left. Also the green of the right flagellant is unique, picked up a little in the dark green of the right outside figure. His boots are ochre, those of the figure on the left are black, while at the center the three officers and Christ all have bare feet. None of these echoes the color of the thin-clouded blue sky, none the green of the trees framing the pinkish-red of the near house.

In the *Baptism* [**Fig. 7**], too, Christ's near-white body is draped by a near-white loin cloth, and that fullness, and also near-emptiness, of color, stands as a measure for the other colors, notably for the color of John the Baptist's light russet tunic to the right. To the left the angels concentrate and vary their rich colors, begin-

ning with the angel on the far left, the only one whose wings show. They are rainbowed as they fold against the pearl-trimmed red upper garment and the dark blue lower one, against the green of the ground on which the angels stand. This first one has his hair bound by a simple cord, held by a pearl ornament at the forehead.[76] The angel next to him, whose garment is as simple as Christ's, wears a coronet of white and red roses. A myrtle wreath crowns the third angel, who wears a pinkish cape over a violet gown. The other concentration of color in the work, breaking the browns, light and dark, of the landscape, are spread and also densely collected on the garments of the small oriental figures, who are partially blocked, and also segmented by the stripping catechumen, at whose feet the bend of the river fills solidly with the red, orange, and blue range of the mirrored oriental garments.

Color reinforces perspective, and we assimilate the two in a kind of stereoscopic juncture that contains, measures, and also fills out, the arresting of our immersion. In the regular perspective of the *Flagellation*, the sharply contrasted blacks and whites of the floor pattern on which Christ stand also serve as an elaborate grid for the picture's receding planes; and at the same time these squares are slanted into lozenges, at an oblique angle, as though the perspective were only suggested, the way such a sharp contrast of three-dimensionalized diaper pattern is segmented behind the Virgin in the Annunciation panel of the Arezzo frescoes. "(In) the Sheba-Solomon episode ... the two pages balance each other almost like playing cards, one facing us, one showing his back, one in a white hat, one in a black, one in a red doublet and grey hose, the other the reverse, and so forth through every detail."[77] A comparable elaboration is accorded the color for horses of this work or *The Victory of*

Constantine, and for the colors in the hats and costumes of *The Defeat of Chosroes*. And as Clark says of the lances in the former, "Only two of them are completely white, and they are in the background, thus giving relief to the others. From graded white they work up to buff and grey, warm and cool, some even pink, others mole color, finally green and yellow. The whole of this passage, with its two strange white balls pitted like moons...and its saffron banner counterbalancing the chill of the pale blue sky." A play within the closer range of possible gradations of olives and greens is found in the Brera *Madonna*, and differently in the Williamstown *Madonna* [Fig. 11], where the four angels flesh out their full cheeks and fold the blue blurs and soft shapes of their simple wings in another windowless interior of white pillars, white entablature, red and green stone background. This red is also picked up in a slab underneath the white stair where the Virgin sits, her garment lined in red, while the giant, white naked Babe, held upright, reaches for the pink flower she is holding.

The splendid garb of Solomon as he receives Sheba in the Arezzo panel [Plate 3], his brown exterior cloak and rich but pale blue interior gown, is variegated as though to celebrate the effect of texturing and to approach a geometric design in curves rather than in cones and squares. These designs are elaborately of leaf and flower patterns, on both brown cloak and blue gown. Sheba's plain gown, like those of the others present, carries no ornament at all, though the translucent white veil atop her hair offers a counterpart of delicacy to the richness of Solomon's garb. Their handclasp takes place at the soft center of his blue gown. This almost tactile attainment and also bewilderment of the fusion of perspective and color allows for our identification into the fulfillment of the mysteriously

uncoded ceremony, for which the color can be taken sub-symbolically to stand, a ceremony royal and of much-muted sexual charge in its presentation, awed and monitory and at the hinge of its connection to the legend of Solomon and Sheba—a hinge that we can say is oiled by the rich slide of redistributed colors through and across this whole panel and its mate, the more pronouncedly that the tall white fluted pillar dividing the two, and also joining them, as well as the smaller pillars behind them, frames them so that the perspectival vise both squeezes and opens out the bearers of these colors.

This variation in the perspective brings the centrally located body of the spectator into play. It has the effect of pulling him round and pulling him in, the more that the next panel will have some other perspectival system and will use this disorientation of the eye to orient him further towards itself, and then visually to provide for his vision a system that will steady him at the center of the variations. He will generate an abstract grid within which he can easily locate the variations of perspective and move with them as he looks round and takes in the measured bodies panel by panel. Then, too, the alternating patterns of color in their chiastic and superchiastic blocks provide a reinforcement of ordering and of movement as the eye assimilates, moves through, and organizes them.[78]

In another fusion of perspective and color in *The Finding of the True Cross* [**Fig. 9**], the crosses that are not true are on the left of the long panel, dominated by a distant elevated hillscape of a town blocked in earth colors inside its white walls, cut by an almost horizontal cross close at hand below it, in the standard light wood color of nearly all these crosses. This scene is divided by hills richly

mottled in green and brown above fields set out in rows, from the actual presence to the right of Helena before the True Cross. This right half is in close-up, and as though turned one hundred and eighty degrees from the other half, at a ground level town square of more pronounced earth colors, dominated by a simple temple faced in rectangles and circles of brown and green marble. The largest window on this temple is a pale blue, and the temple itself, flat to the picture plane, squares out, walls off, and hieraticizes the scenes in which Helena kneels before the Cross. The towers of the town in their own blocked colors proportionately recede past an alley diagonally bisected by the tilted True Cross. And again, I have spoken only of the upper part of the picture, the dominant two thirds. Below, and importantly on a par with the pale brown crosses, are two groups of people, arrayed in solid blocks of what are also whites and contrasted earth colors, both those standing around Helena as she supervises the exhumation of the crosses on the left, and those kneeling around her or standing to observe her as she worships the True Cross on the right. More than a dozen colors are graded through the picture. The blues are themselves graded, from the rich one across the unusually narrow elevation of the sky and the darker one interspersed with red in the cloak of the handmaid directly behind Helena to the paler blue of the handmaid to her right, of the hat of one of the observers and the shirt of another, to the slightly less pale blue of the largest central church window. But all the other colors are earth colors, starting from the prominent whites to red, rose, umber, brick, green, orange, slate, brown and black, each of these colors firmly segmented in its application to wall and tower and slope and facade and gown.

The *Baptism* is a moment in time, frozen by the rapid falling
away of the Jordan from the feet of Christ, the "Miracle of the Jor-
dan." Time is more elaborately at once evoked and "suppressed" by
Piero in the True Cross sequence. First of all, the story of the True
Cross hangs together only loosely; it is unified, but its events are
episodic, each remotely connected to the other, unlike the usual bible
history. But also, in a tonal unity, each episode is strung on the sin-
gle motif of the transmission of the cross. Both the unity and the
episodic variety have the effect of suggesting, just through the ico-
nographic choice, the long span of time involved from Adam to Her-
aclius, and also of suggesting that across that long span of time the
attention should rest, for this meditation, on a single factor, the
Cross. The natural and proportionate elaboration of the panels here
itself rests on that evoked assumption, interpreting it while sublat-
ing it. Alberti speaks of *istoria* in simple terms, and refers minimal-
ly to the story to which a painting may refer. The later convention
of history painting, from Rubens' cycle on Henry the Fourth to the
various mutations in the late eighteenth century, perduring through
the nineteenth, carries more specifically the message of celebrating
the glories or even the horrors of nationalistic enterprise by locating
some actual event of strong legendary resonance within the grid of
the elaborately planned grand scale—Napoleon in Egypt, Washing-
ton Crossing the Delaware, Ivan the Terrible and his Boyars, the
Third of May.[79]

Now Piero retains the grid; and the authority of the Bible
pulls the audience of Sheba with Solomon into historical focus, while
neutralizing it away from the sequence. This meeting happens at
too long range, too little figurally, for the visual and confrontational
enrichments of the single panel. Its analogies with the battle
against Chosroes or the triumph of Constantine are secondary. And

The Finding of the True Cross evokes nothing national, even though it incorporates strong reminiscences of the local by taking San Sepolcro as the model for the town behind the action in the foreground. The town, in fact, gives the action an archetypal, and also a contrastive cast. The town mutates the complex juxtapositions of the participants away from their exclusive preoccupations, just as the languidity of horses and the limpidity of the mirroring stream do for *The Victory of Constantine.*

For Piero already apposite are the coordinates that Harry Berger defines for Leonardo's disposition of his own capacities and fascinations through space:

> The essence of the panoramic mode is *observation*, the act of perceiving and noting large- and small-scale forms of the universe as they appear to the eye. The essence of the analytic mode is *penetration* beneath the diversity of forms in search of basic causes or principles. The essence of the analogical mode is the *coordination* of forms and causes into a dynamic and implicitly systematic vision of existence; in this vision, a few basic natural processes operating throughout space-time produce similar effects in the most diverse phenomena and events. The essence of the apocalyptic mode is the *fascination* with destructive power; here, the aphoristic pessimism of Leonardo's natural attitude is directed away from its proximate causes, is magnified, intensified, and universalized into a vision of elemental fury and cosmic doom.[80]

78

The *observation* of large and small scale forms in the *Baptism*, but also in the panels of the True Cross cycle, is subserved by the *penetration* with which basic principles within the painting are brought forward, mysteriously but so definitely that they are locked into the plenitude of their significations, with no trail-off of anecdotal surplus. Thus are they *coordinated*, to the point where they are intensified into a *fascination*, not with Leonardo's expansive turbulence but with an overarching and undergirding calm.

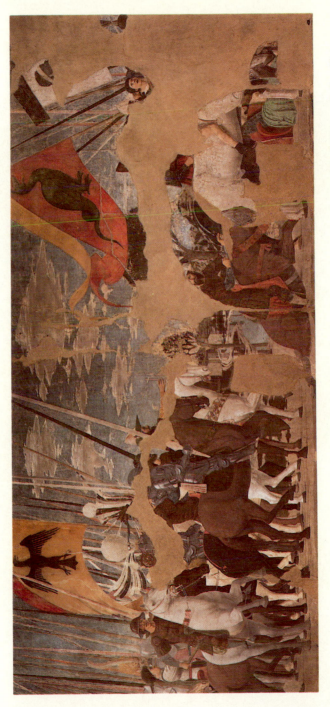

Plate 1. *Victory of Constantine*, from *Cycle of the True Cross* by Piero della Francesca. Courtesy of Chiesa di San Francesco, Arezzo and of Alinari/Art Resource, New York.

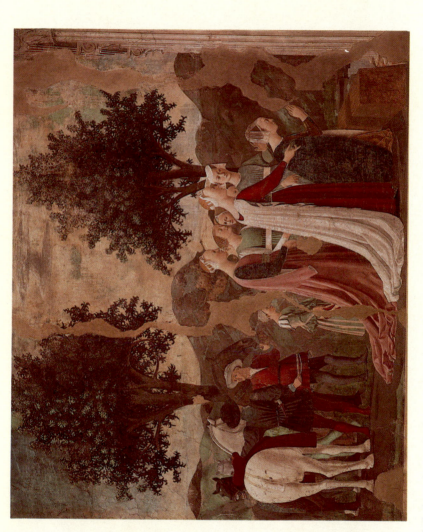

Plate 2. *Queen of Sheba Adores the Sacred Wood*, from *Cycle of the True Cross* by Piero della Francesca. Courtesy of Chiesa di San Francesco, Arezzo and of Alinari/Art Resource, New York.

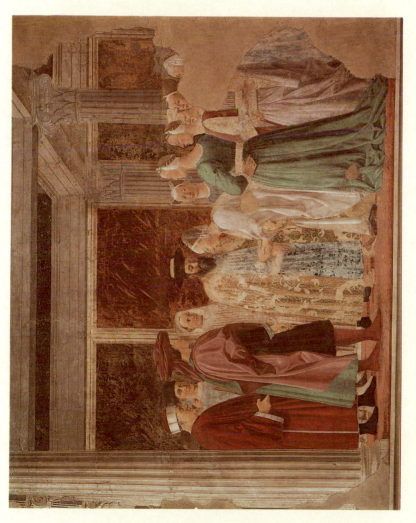

Plate 3. *Encounter in Solomon's Palace,* from *Cycle of the True Cross* by Piero della Francesca. Courtesy of Chiesa di San Francesco, Arezzo and of Alinari/Art Resource, New York.

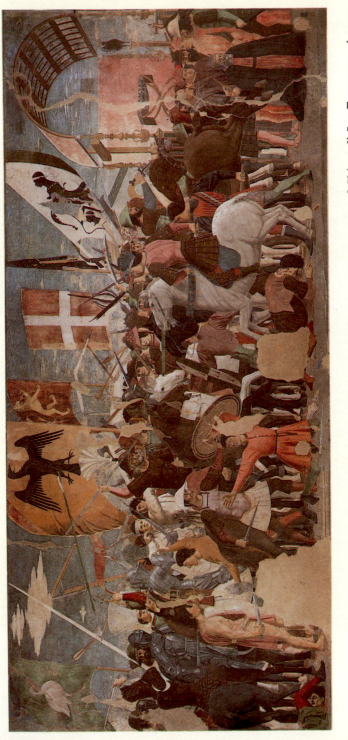

Plate 4. *Defeat of Chosroes*, from *Cycle of the True Cross* by Piero della Francesca. Courtesy of Chiesa di San Francesco, Arezzo and of Alinari/Art Resource, New York.

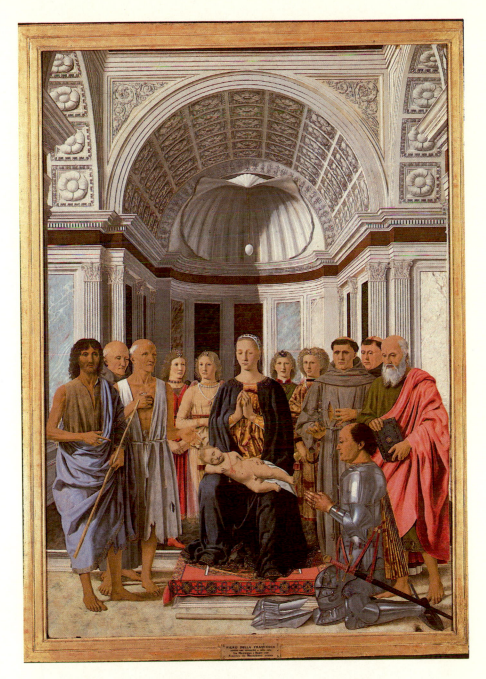

Plate 5. *Madonna and Child with Saints*, by Piero della Francesca. Courtesy of the Brera, Milan, and of Alinari/Art Resource, New York.

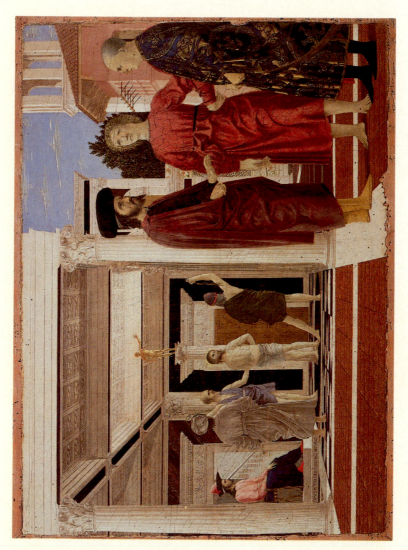

Plate 6. *Flagellation of Christ*, by Piero della Francesca. Courtesy of Galleria Nazionale delle Marche, Urbino, and of Alinari/Art Resource, New York.

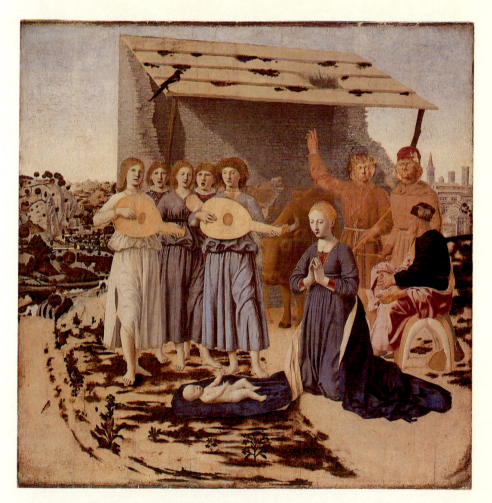

Plate 7. *The Nativity*, by Piero della Francesca. Reproduced by courtesy of
the Trustees, The National Gallery, London.

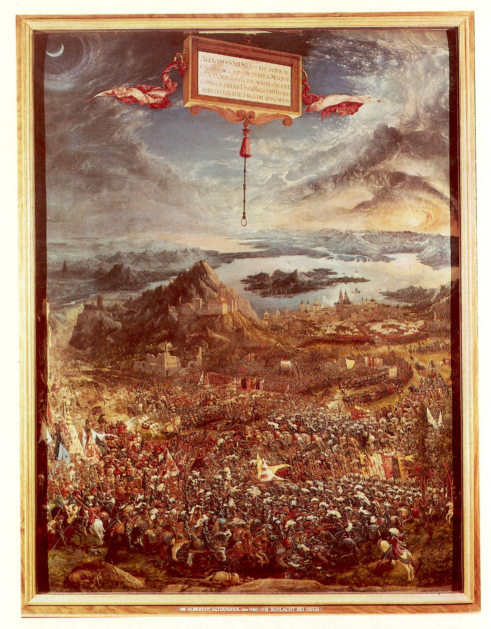

Plate 8. *Battle of Alexander*, by Albrecht Altdorfer. Courtesy of Alte Pinakothek, Munich, and of Alinari/Art Resource, New York.

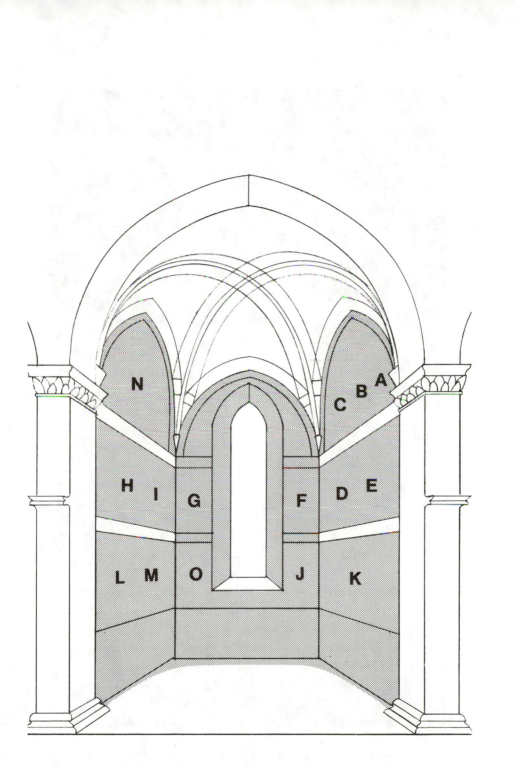

Figure 1. Diagram of the *Cycle of the True Cross*, by Piero della Francesca.

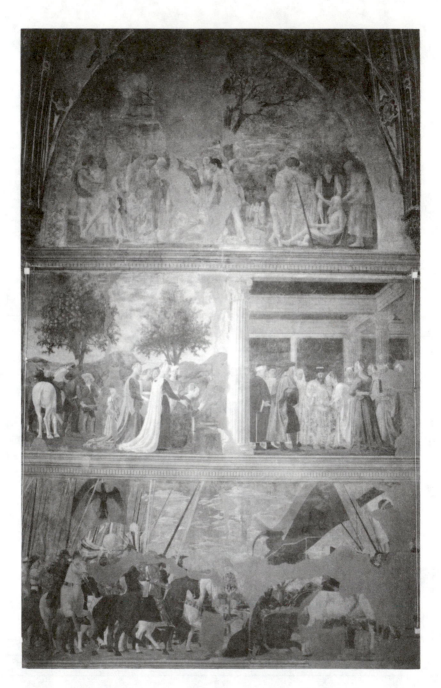

Figure 2. General View of the *Cycle of the True Cross*, by Piero della Francesca. Courtesy of Chiesa di San Francesco, Arezzo, and of Foto Gualdani, Arezzo.

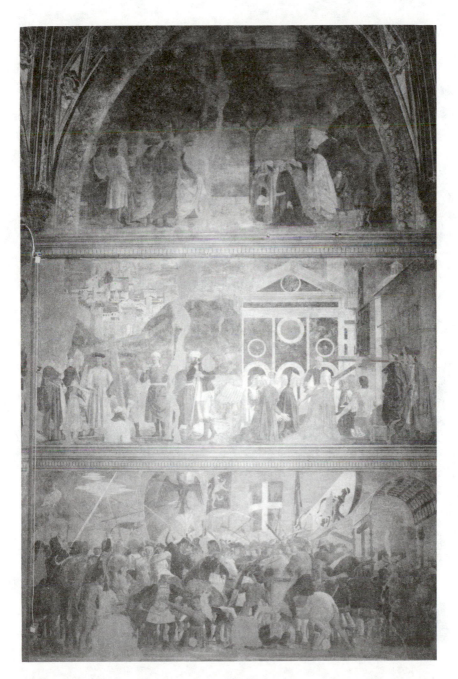

Figure 3. General View of the *Cycle of the True Cross*, by Piero della
Francesca. Courtesy of Chiesa di San Francesco, Arezzo, and of Foto
Gualdani, Arezzo.

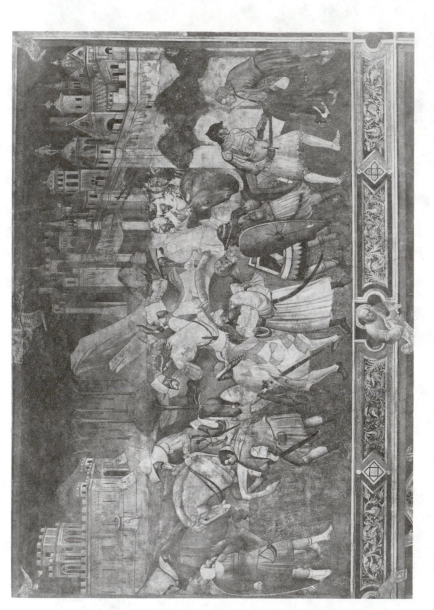

Figure 4. *Defeat of Chosroes*, by Agnolo Gaddi. Courtesy of Chiesa di Santa Croce, Florence and of Alinari/Art Resource, New York.

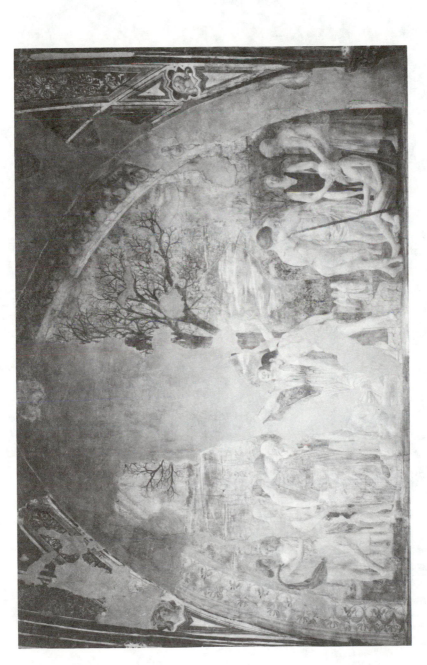

Figure 5. *Death of Adam.* from *Cycle of the True Cross* by Piero della Francesca. Courtesy of Chiesa di San Francesco, Arezzo and of Alinari/Art Resource, New York.

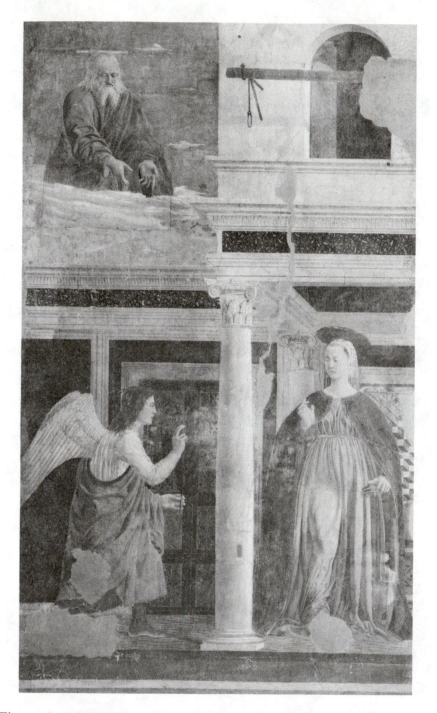

Figure 6. *Annunciation*, from *Cycle of the True Cross* by Piero della Francesca. Courtesy of Chiesa di San Francesco, Arezzo, and of Alinari/Art Resource, New York.

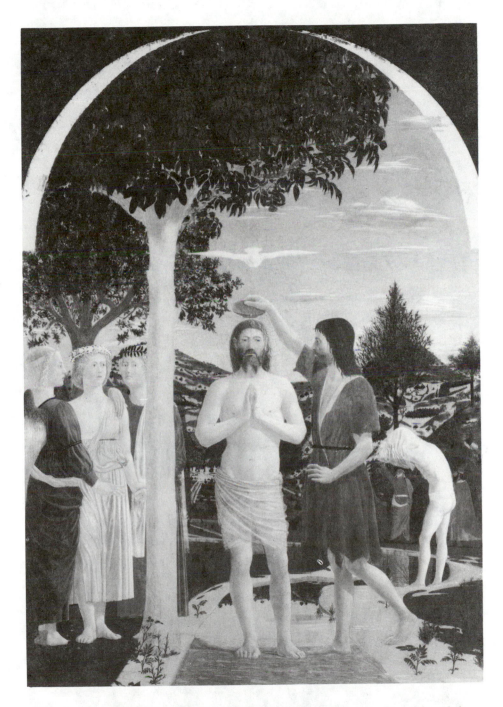

Figure 7. *Baptism of Christ*, by Piero della Francesca. Reproduced by courtesy of the Trustees, The National Gallery, London.

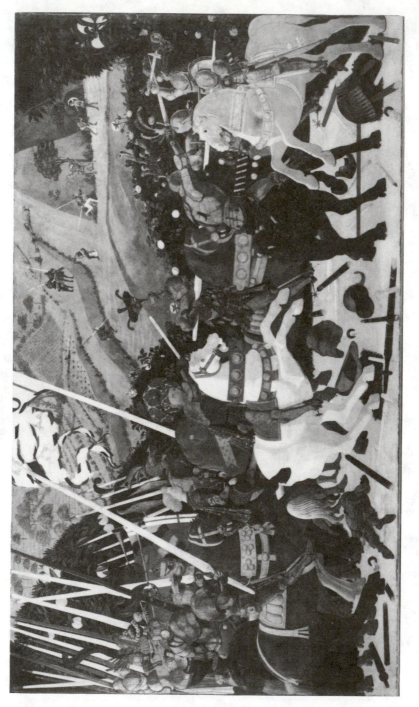

Figure 8. *Niccolo Mauruzi da Tolentino at the Battle of San Romano*, by Paolo Uccello. Reproduced by courtesy of the Trustees, The National Gallery, London.

Figure 9. *Finding of the True Cross, from Cycle of the True Cross* by Piero della Francesca. Courtesy of Chiesa di San Francesco, Arezzo and of Alinari/Art Resource, New York.

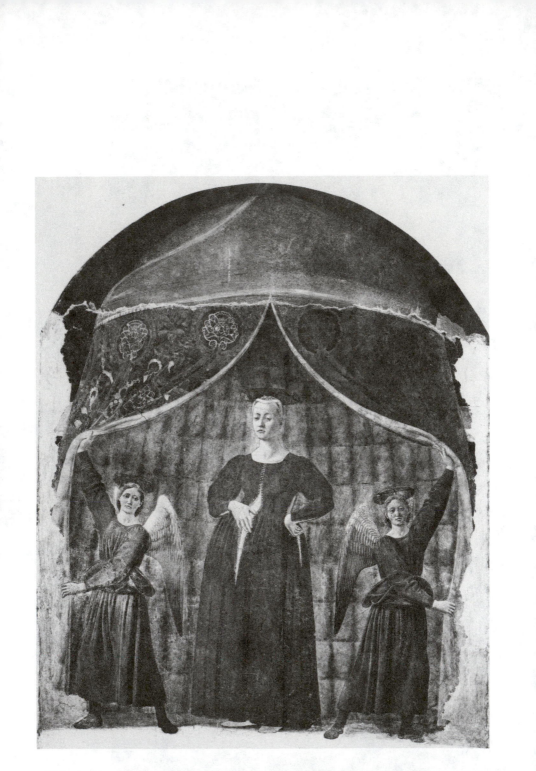

Figure 10. *Madonna del Parto*, by Piero della Francesca. Courtesy of Cappella del Cimitero, Monterchi, and of Alinari/Art Resource, New York.

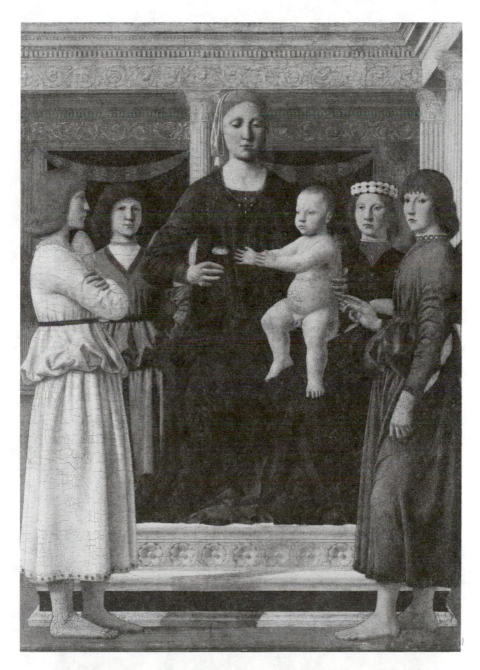

Figure 11. *Madonna and Child with Four Angels*, by Piero della Francesca. Courtesy of Sterling and Francine Clark Art Institute, Williamstown, Massachusetts.

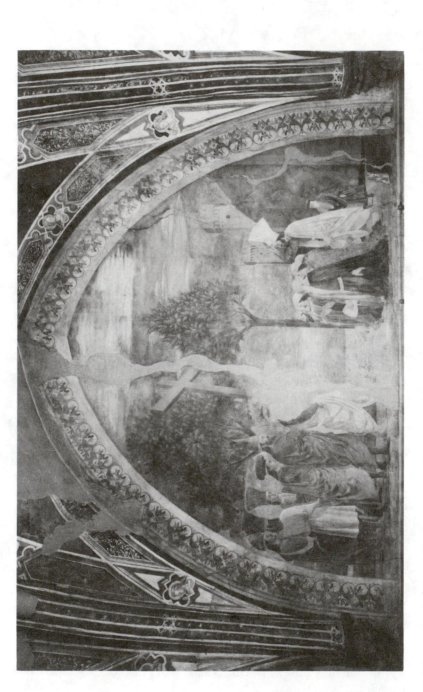

Figure 12. *Exaltation of the True Cross*, from *Cycle of the True Cross* by Piero della Francesca. Courtesy of Chiesa di San Francesco, Arezzo and of Foto Gualdani, Arezzo.

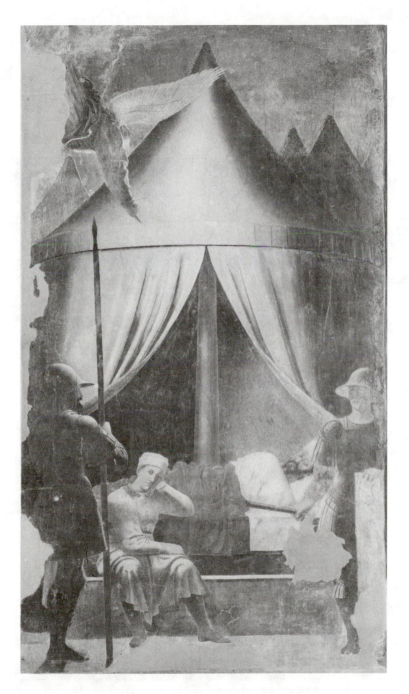

Figure 13. *Dream of Constantine,* from *Cycle of the True Cross* by Piero della Francesca. Courtesy of Chiesa di San Francesco, Arezzo, and of Foto Gualdani, Arezzo.

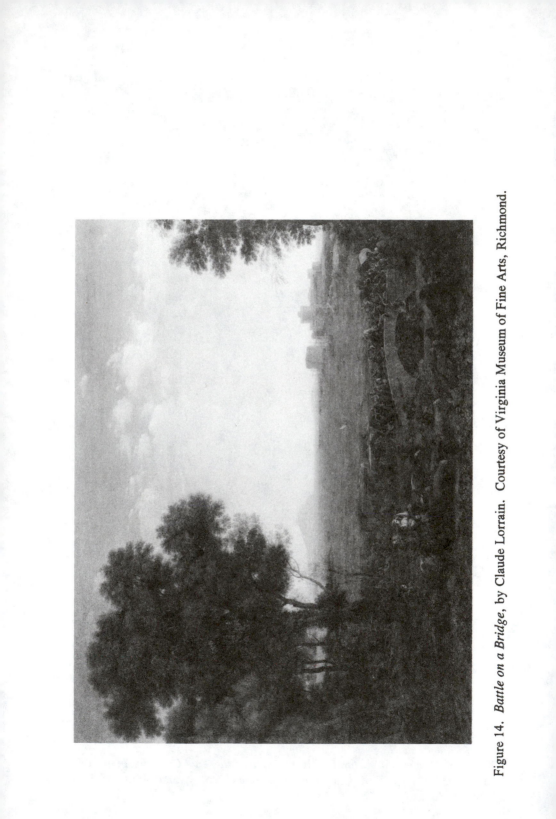

Figure 14. *Battle on a Bridge*, by Claude Lorrain. Courtesy of Virginia Museum of Fine Arts, Richmond.

Figure 15. *Ideal City*, by Piero della Francesca. Courtesy of Palazzo Ducale, Urbino, and of Alinari/Art Resource, New York.

Figure 16. *Saint Theresa*, by Gianlorenzo Bernini. Courtesy of Chiesa Santa Maria della Vittoria, Rome, and of Alinari/Art Resource, New York.

PART TWO

MODULATIONS OF SPACE

Nos deux espaces immémoriaux: le premier l'espace intime où jouaient notre imagination et nos sentiments; le second, l'espace circulaire, celui du monde concret. Les deux étaient inséparables ... Est-il un troisième espace en chemin, hors du trajet des deux connus?

René Char, "Aromates chasseurs," *Le Nu perdu*.

Modulations of Space

We experience a painting or a group of paintings, and we then confront our experience by asking what it has been. The experience itself reverberates; it has a splendor that may lead us to try to account for it. Space must be involved; the painting in various ways utilizes and interprets space. But time is involved too. Just these large categories themselves, space and time, introduce problems for the interpreter which, like all philosophical problems, may turn out to be endless. So we are caught in at least one paradox, and actually in many.

These lead us back to the signs in a work of art, visual or verbal. Now signs in themselves are intellectually constructive. If written, their visual properties are accidental, except in certain "concrete" poetic effects, which move towards the border of the visual arts. In a painting, however elaborately we pay out the conventions and combinations that enter the constructive act, the visual properties remain foremost. Still, the intellectual properties of signs in paintings do help bring about the constructive, and then the immersive acts of a viewer. On the solid basis of the work's special space, the visual properties assist construction and the overtones of integrated viewing that transcend construction at every point; they provide the illusion, and then a psychological reality, of immersion. We stay, in actuality or in memory, in a space where our intentionality is engaged in looking at the painting. We do not come to the end of it, as we do come to the end of a poem, and our memory of

the poem's complex message reverberates from our having run through the sequence of its arbitrary auditory cues. The visual cues of the painting, on the other hand, first and last fuse into its visual message, however associationally coded. The constant externalization in a painting, a corollary of its insistent spatialization, itself creates the sense of transcendence in the immersion that must, finally, be discussed, however elusive it may be, since the immersion in the last analysis is what gives more than a documentary or antiquarian interest to the painting. This will be so even as paradoxes about space and time remain in place.

As with the paradoxes about imitation and representation, solving those about space and time is in some ways prior to giving an account of the experience.[81] But the experience is also prior to them. In the large specific case of Piero della Francesca's work, and especially of his sequence of frescoes in the True Cross cycle in San Francesco of Arezzo, to match one panel with another in space leads us to account for the relation of one represented moment in time to another. Piero has temporalized space in two senses: he has set out spatial representations in a temporal relationship, and he has produced acts of qualification around them, as I, in interpreting them, am led to do. There is another precondition too—that in doing all this the viewer, like the artist before him, enters for a time into the arrested space that has conjecturally accompanied a consciousness of objects, for perhaps longer than a hundred thousand years. This actual pause, and its intentional act of contemplation, produce an air, or even an aura, of spiritual stillness. To speak of the "stillness" of the art object, what Heidegger calls its "Ruhe," of course, raises other problems, and very pointedly in relation to the primacy of time in our apprehension of a poem, a novel, or a film.

The visual arts and the verbal arts may differ fundamentally in their primary presentation, and their orientation, to space and to time respectively, however much secondary crossing of lines may occur in the temporal apprehension of paintings[82] or in the spatial perception of the literary work. Enlisting and overriding this fundamental difference, long ago pointed out by Lessing, there is not only the complex likeness of significative structures in both the visual arts and the verbal.[83] There is also the deep similarity of what one can call the stereoscopic assimilation of a work, with all its psychological, and indeed ontological, rootedness in spatial representation, "for itself," through its nodes of cultural signification, and also as that rootedness may in some powerful instances be connected to narrative.[84]

In both the visual arts and the verbal we proceed in both a constructive and an immersive fashion. We not only apprehend *Paradise Lost* word by word constructively in the little drama of the line, and then groups of lines, and then book by book. At the same time, however contradictorily, we "immerse" ourselves in *Paradise Lost*. It rings in our ears and echoes in our minds allusively. Just as critics like Stanley Fish who have well delineated the constructive side of this and other poems run the risk of obscuring, or even denying, the seemingly contradictory but actually subsumptive "immersive" side; so those who follow a comparable focus on the constructive side of the visual arts with Ernst Gombrich or even Rudolf Arnheim and Richard Wollheim[85] run the risk of forever deferring a coordination of sense and reference with construction and immersion. Such coordination can be achieved when the painter, and the viewer, pay attention simultaneously to the primacy of space and the enlistment of time.

The Australian bushman's space and time are not those of a modern Westerner—nor are the space and time of Piero della Francesca. Both space and time are governed by a host of conditions in any particular culture. It is possible, in some contexts of anthropological analysis, to map a culture's integers of signification, both small and large, in terms of space. There is a sense in which an earlier culture's sense of space and time are irrecoverable. Yet, like the ethnographic investigator, we try to enter into that space and that time. And then, beyond the investigator, we try to attain and appropriate the perception of the "native." In attending to Piero della Francesca we putatively assimilate to the version of space and even of time that he presents in each work.

● In the *Ideal City* of Piero della Francesca a quasi-Albertian dream is offered; a space simultaneously embraces the viewer because he is positioned as though he might be surrounded on all sides by buildings.[86] This is so because the central temple is understandable according to normal mappings as at the center of a square, the rest of which would be "imagined" behind the viewer—or otherwise, quite improbably, the temple would be at the edge of the city. On that normal construction there is imagined to be as much space, and symmetrically equivalent structures in the empty space behind the viewer, as there is in the painting before him. The city surrounds him, in the imaginary filling out of the phenomenologically empty space. At the same time the city rejects him because the coulisses of the two straight, possibly converging streets are angled so that no entrance is visible except the doors. One door is open, but just a crack, at the center of the ground floor of the two-

story, marble-faced round church, a modified Pantheon with a
sloped roof and small turret instead of an oculus. This painting's
windows, too, are ambiguous to read, even in the natural situation
of an Italian city, where windows tend to be impenetrable, their
interiors dark even at noon. The windows in this painting have thick
slits of a varying width; those slits are uniformly dark, the rest of
each window brown. One tiny window on the third story of the third
house on the left seems open and to be reflecting a sunlight without
source—unlike the rich light in the two Vermeer-like apertures on
the left of the *Madonna of Senigallia*. Otherwise the only windows
that look as though they would admit light are of the type that are
set not to admit views from outside, the reticulated bullseyes of the
glass window on the second story of the Temple and on the match-
ing window of the smaller building behind it to the right. This simi-
lar building blocks the distance down to the right.

The brightest color here is the blue sky; the darkest the
greens in the panels of the round church. There is a shading of pale
greens and roses reminiscent of the actual hues of an Italian city,
and our lack of access to an imaginary entrance to these interiors
throws us back to the surface of the exterior. These thirteen or so
visible houses are on three or four modular patterns. Arches and
porticos blend to a repetition-with-variation that could be taken to
suggest the patterning of persons and social structures in the ideal
city. Such an ideal would be actualized in the town plans of a centu-
ry or so later.[87]

Both the smaller upper stories and the larger ground stories
of the round church, where in a church of Piero's time might have
been some window apertures, are faced instead with green marble
insets of a sort found *inside* churches and so suggesting an interior.

For the viewer, interior and exterior play off against his perceptions, and work toward integrating them.

● So it is when we arrest ourselves before this painting, or another. When we move actually through our world and interact with it, we cannot help being totally immersed in it, and it is itself in motion. But when we arrest ourselves before a painting, we are not only immersed; we contemplate our own immersion. The act of contemplation and the act of seeing are one, a composite act in which our arrest from the flow matches, caps, and fuses with the painting's own act of arrest into immobility of that which it has managed to represent. It, and we, leave all the prior constructive acts behind, constitutive as these may be for our contemplation, our "seeing-in," to adopt Wollheim's phrase.

It is different with a book. The book can be treated as an object "out there" and admired for its design, typography, redolent antiquity, or whatever. But this is to treat the book as an art object (which it incidentally is). When we actually read the book, the fact that it is "out there" is incidental. We are involved in assimilating a text, and the text reverberates in our own interiority, with the faintest reference to black marks on a page or even a voice on a tape. Even the script of a play reverberates in our interiority as we go through the constructive act (which requires some practise) of imagining it as though it were staged. In reading, the flesh of the world remains unmediated, whereas the arrest and rest of the painting begins by mediating the flesh of the world. Looking at the painting, we position ourselves to take it in, and thereby to take in a new awareness, spatial and spiritual, of our position, physical and spiritual.

● Between ourselves and this "flesh of the world," speaking generally, there is an "interlace," an "entrelacs" in Merleau-Ponty's sense, an act of reflection connecting and reconnecting us to what we are perceiving that depends on our attention; this whole process of reflection is deeply based on the thereness of the world. But there is also, to continue with his language, a "chiasme," a crisscrossing that involves a split, an ineradicable otherness in the sense of what we see—a split intensified and then paradoxically resealed when the object has been arrested into stillness from the flow around us.

We get our sense of our own bodies partially, feeling an elbow or seeing a foot. We cannot see behind us, and we cannot see even an image of ourselves in a front view without looking in a mirror. We can only conceive of them wholly once we go through what Lacan calls the mirror stage, of seeing that others see us as other, and so, seeing them whole, we imagine ourselves seen whole as seen by the other. Now in the interlace of our attention to some display of visual representations like Piero's *Ideal City*, or of his whole cycle on the True Cross, we go through an ideal version of this process. We see other bodies, or objects or structures or expanses, but those bodies are only representations, and the flesh of the world stays steadily theirs because they are a representation, returning them to the act of reflection that is a heightened consciousness of ourselves. They reassert the chiasmus, these painted bodies—or buildings or mountains or trees or gardens— by being "out there." But they transcend it by being painted in such a way as to cohere, to form an order that has been assembled by the painter. To do this the painter must enter into a fiction that turns color and space to this use. As Merleau-Ponty elsewhere says, "It is in lending his

body to the world that the painter changes the world into painting. To understand these transubstantiations, he must rediscover the actual, operant body, one which is not a piece of space or a bundle of functions, but which is an interlace of vision and movement." Thus he overcomes the paradox between motion and stillness, whether he be the painter of an Egyptian frieze or a Piero playing fast and loose with a highly developed perspectival system.

When the painting is successful, it manages this interiority which Cézanne saw as the truest nature. In the *Ideal City,* like di Chirico long after him, Piero has made the closed buildings bear upon the paradox of interiority and exteriority. "Quality, light, depth," Merleau-Ponty says, expanding on Cézanne, "which are there before us, are only so because they awaken an echo in our bodies, because it gives them welcome ... Then there appears a visible to the second power, a fleshly essence or icon of the first ... This vision, being a thought united to a body, cannot by definition be truly thought."[88] Even sculpture, the assertively three-dimensional spatial art, manipulates the temporal as well as the visual, as again Merleau-Ponty cites Rodin, "That which gives movement is an image in which the arms, the legs, the trunk, the head, are each taken at a different instant, and so figures the body in an attitude that it possesses at no particular moment, imposing fictive accords among the parts." The unnaturalness and therefore the total ideality of stillness, includes the viewer and automatically three-dimensionalizes him.

● Space flows around us, inseparable from time in a continuous

movement, the "image-time" and "image-movement" that Gilles Deleuze finds to be coordinated in cinema.[89] Even cinema, of course, abstracts, as it must, to organize and suggest. But outside the darkened theater the real world continues to flow around the flowing film. When the object of sight is arrested it envisages something unnatural: the fixity of a notion of timeless space. That unnaturalness splits the viewer from his object, but at the same time the unnaturalness paradoxically rejoins him to it, forcing an act of contemplation derived by the very excerpted absence of the object from the flow for the moments of looking. "Bold lover, never never canst thou kiss," Keats says, of the figures shown as arrested from a flowing fulfillment on his Grecian Urn. But there is a corresponding, counter-natural yield or effect from this fixity, "Forever wilt thou love and she be fair."

The impression of fullness in the still life painting derives from its having selected a subject that already incorporates a stillness from the flow: the immobile apples and pears, or bottles and knives, or oysters and fish, or animal carcasses, are, so to speak, doubly still—in the world as it flows around them, and in the painting as it arrests their arrest. So the unpeopled emptiness of Piero's *Ideal City* broaches a comparable fullness, using up as well as filling out its space, and the more so that it presents no apertures for penetration, no windows that can be opened or doors that can be entered.

● In another extremity of technique the photograph arrests the moment it represents. A photograph, first of all, thrusts upon the viewer not only a selected representation but a reminder of the

moment at which it has been put through advanced technical means to arrest that representation from the flow. The act of arrest, for scientific or artistic purposes, can be highlighted by the image itself, as in Muybridge's photographs of arrested motion or the micro-second photographs of one liquid drop when it is dropped into a body of liquid, creating the instantaneous pattern of a crowned circle splashing around the dropped drop. The moment cannot return: this is what the photographs of the furtive, revealing gesture or look tell us in candid work of Cartier-Bresson's type. In the title used for some of them in the magazine *Verve*, these are "images à la sau-vette," "images with the quick getaway," on the analogy of a clan-destine merchant who must pack up rapidly in order not to be arrested. Their pure presentness is caught in their pure pastness, for all the complexities of Barthes' theory of the *studium* the overall feeling of an individual photograph, and the pointed *punctum* or secret hook of a most telling detail. The presentness and the past-ness of a photograph frame and extend the *studium* and the *punc-tum*. So it is in such photographs in *The Family of Man* as that by Nat Farbman in which the relaxed but attentive naked son of a Bechuanaland hunter stands in back profile behind his nearly naked father, who is crouched with distended muscles in a similar posture aiming his spear at a grazing ibex. The transmission of techniques from father to son has been rendered visible at an arrested moment of pure presentness in a remote locale, but so has the slow repeti-tion across generations, a repetition founded on thousands of such imitative gestures. Related within the same album are the seven photographs of couples who across some decades of marriage have come to resemble one another: their slow convergence of feature is registered in this junction of present and past where the moment

reveals, and will continue to reveal, the decades. These connections are rendered visible through, and beyond, the cultural connections making the photograph and its dissemination possible. They also hold through and beyond the silent syntax of the mythologization that Roland Barthes points out for this very album, "placing Nature at the base of History."[90]

In this complexity the photograph may lack an aura; yet it retains the complexity we bring to the art work that does have an aura, especially in the "sublime" natural landscapes of Ansel Adams or the abstract ones of Edward Weston; or in the dense and structured houses of Paul Strand, the segments of wall or pavement of Aaron Siskind. And auras can be provided for photographs of persons: by Julia Cameron or Cecil Beaton or Richard Avedon or even Diane Arbus, whose auras, bitter and as though stained, come through strongly, and in spite of what she called the "flaws" in her subjects.[91] The harshness of photographs of violence or suffering or misery may have its own aura too, an aura not incompatible with the dignity of composure, as the work of Walker Evans shows.

● A person can surround the art object in space, as with the Grecian urn, imagined or real—or as with the hand-sized portable object of the paleolithic carving. Or the object can surround him, as in the paleolithic parietal painting, where the painting need not be confined to a single wall (though it tends to be so confined on the small scale of La Moute or even preponderantly on the large scale of the rooms at Lascaux). One can confront the object, as in a painting or a frieze, or for that matter on a stage. The act of confrontation can pretend to include an act of surrounding, as in perspective

and in three-dimensionality. Surrounding can be dynamically alter-
nated, and the viewer of an art object or the apprehender of an
architectural space may use his eyes as the lover is to use his hands
for an approach to the love object in Donne's "To His Mistress
Going to Bed": "License my roving hands, and let them go/ Before,
behind, between, above, below." The easel painting small enough
not to cover a whole wall can be surrounded, as a portable object
can, by the viewer. But it can also be angled to surround him, as in
Piero's *Ideal City*, and the more that this particular painting makes
a visual point of not including him, while positioning him conjectur-
ally at the center of a city. If this painting be taken as an analogue
for the set to a theater—though its feature of impenetrability, and
also its centering, would argue against that specific interpreta-
tion[92]—then it would refer to as well as set the circumstances for a
separation between its space and that of the viewer.

These two schematic dispositions of arrested space in an art
object are already to be found in what we perceive as the paleolithic
beginnings: the small, three-dimensional, object for holding in the
hand, which the viewer surrounds, and the object painted on a wall,
which surrounds the viewer. The second, indeed, comes into devel-
opment no sooner than ten thousand years after the first. Neander-
thal man had the hand-held objects, already a hundred thousand or
even three hundred thousand years ago, if pierced animal teeth pre-
sumably to be used for ornament be accounted such objects.[93]
Three-dimensionality, in fully developed Solutrean hand-held
objects, precedes by millennia the two-dimensionality of the wall
paintings, and in that sense the latter is a perspectival development
which requires inferences and mappings, where the former can be
carried out with the simple (but highly evolved) representational

skills of the carver. But the hand-held object is "out there," very much like the animals which it often represents. The wall painting moves the "out there" to "in here," and thus involves a deep transposition as well as inferences and mappings; exteriority and interiority have already entered into a dialectic. But the two possibilities remain paradigmatic for all art produced by human beings, and also combinable in a dialectic; one surrounds, or else is surrounded. To adapt Hamlet's words, one is bounded in a nutshell, or else one opens on infinite space.

● A sculpture or a painting invades and doubles our space, where a book, held and read or listened to, does not do so. It does not raise the question of its presence in space, though it may, and in fact must, evoke space, but always virtually and verbally. Consequently the uncanniness Naomi Schor brings to bear as a definer on the clothed, and therefore costumed, super-realistic sculptures of Duane Hanson does not at all hang over the realistic novelist, like Balzac.[94] If Hanson is the Balzac of sculpture, his effect is very different from Balzac's. Not only because the categories have been erased by which the ornamental and the essential are decided (to follow Schor), and not only because we cannot decide immediately whether or not they are alive (to follow Freud), does an air of the uncanny hang over them. By carrying the doubling of an imitated body into space to the extreme through extreme technological means, the sculptures of Hanson and others in his tradition force on our attention the always lingering uncanniness of the arresting of time through space. The fact of the arrest is emphasized by the convergence of the likeness of the art work to actual bodies in time,

a feeling we may assume would not have troubled the birds pecking at the fruit of Zeuxis in the famous anecdote. They would not be caught in the nets of coding and doubling that brings the body of a human viewer into Merleau-Ponty's "interlace" of participation.

We are not puzzled by the indeterminacy between the incidental or ornamental and the essential in our actual flow of living. And in fact the anthropologist and psychologist have taught us, as a working principle, that no detail is ultimately uncoded in any case; there is really no such thing as an incidental detail, just as there is no such thing as an unmapped space. Psychological nature, too, knows no vacuum. But the fellow humans, coded to the teeth, who move around us through our world, flow around us in open time as we do, whereas their doubles in the sculptures of Duane Hanson, equally coded, arrest us into an uncanniness, a reaction that through the arrest intimates questions about the boundaries between space and time, and also between life and death. There are also nude superrrealistic sculptures, and they sharpen the viewer's sense of the coding that is involved in nudity, as in costume.

Costume, from hat or its absence to footwear or its absence, presents the self in space and modulates the space in painting, as does the absence of costume generally, the nudity on which the painter allows his subject to merge the more fully with the space it inhabits by a fictive suspension of the social rule that we should not look unabashed at the nudity of another.

Such a situation is schematized into ideality by the white, postured, sometimes grouped figures of George Segal. These are also, like Hanson's, set out from plaster casts of live persons, but they are left without color and shaped in the plaster. Segal, far from furnishing his plaster casts with Hanson's detail, leaves them

in the ideality of the white plaster, rendering them in the stark and stripped difference that asserts some kinship with the spare figures of Giacometti. The white strips them as though they were carved, but the filled-out exactness of the cast builds them up as though they were modelled — and the classic distinction between carving and modelling has been bypassed. As Irving Feldman says of Segal's sculptures, they "come racing in place from all the way back/ to stand in no time at all."[95] But they are also as though bled, "Sadly, it's the dead themselves they resemble." The whiteness suggests a perfection, as Feldman says, but also the ghostly unreality of death. Whiteness also suggests a sort of stupor, a one-dimensionality that differentiates them from us as they can be taken also to merge with us. In a time of conceptual art, they leap over the concepts they themselves evoke by the white-emphasized muteness of their presence in the visual field, evading Hanson's detail while duplicating Hanson's plaster-cast exactness of shape and leaving in space the big question of the overall whiteness.

In this they people our space obliquely, with a mechanism akin to that by which the surrealist painter crowds his space head-on, making apparent and indeed ostentatious his equivalent for a Freudian analysis of dream-work. To assimilate a surrealist art work is not exactly to perceive the real world as surreal, *pace* some surrealists — just as Duane Hanson is not simple, *pace* Duane Hanson. Rather, it is to decompose the world in order to recompose it more complexly, as a Cubist portrait brings about a finer perception of the dimensions and multiple angles of an actual face. In this the end of surrealism resembles the end of Cubism, a non-dream that does not so much mirror a dream as mediate between dream and reality more powerfully than a dream itself could on its own. The

painting belongs to the conscious, not the unconscious, and thus res-
urrects and enlists the power of the unconscious without, like the
dream, remaining unconscious. The painting also mediates more
freely than a psychoanalyst interpreting a dream. The surrealist
juxtaposes in space particulars not habitually juxtaposed, raising
questions that at the same time compose into an equivalent for
answers.

● Constructive and deconstructive are of a piece. Gombrich on
the one hand and Derrida on the other, for all their differences, need
not stall us at *différance*, and we need not share their common
assumption of an exclusively sequential consciousness. If the con-
sciousness, specifically the consciousness of a work of art, did not
move towards a final simultaneity, towards immersion, we would in
fact be at a loss to find a motive for our turning so compellingly
towards it. This "transcendent" apprehension of the work is that
towards which all our constructive and sequential perceptions are
building. That immersion is distinctly and finally what we are
about in looking, if the value we assume in looking may hold in the
face of terms like "connoisseurship," terms that may be taken to
play down the transcendence by emphasizing contributive features
of trained recognitions and expert discriminations. As always in
theoretical discussions, there may be a loss in leaving certain puz-
zles unsolved or even unfaced. But there is the corresponding gain
of moving immediately to the question, itself also endless, of what
there is about the work of art, in words or paint or stone or notes,
that absorbs us.

In a painting we are inescapably involved first with space, but then, through the complex interconnection of narrative moments in such works as the separate panels of Piero's cycle, with time—in a way that brings us to a reimmersion, so to speak, in the painted space distributing interconnected significations to the sight that enraptures us. We well understand in other cultures at least the principle of interconnectedness throughout the coded elements in society, of the Indonesian shadow puppet play, or Greek tragedy (both with strong visual elements), of Australian alcheringas, Chinese mirrors, Etruscan tomb sculptures, Ashanti weights, Bamileke masks, Haida totem poles, or Benin heads. It is not just adherence to a formulable religious system, as for Renaissance painting, that produces this interconnectedness. More enigmatically, under increasing secularization, the uncanniness of producing images persists. The process of doing so remains haunted by the paradox that images at once fascinate and revulse us; idolatry and iconoclasm hang on as inescapable ambivalences. As Ernest B. Gilman characterizes the process at a key moment of transformation to the modern era, "From one point of view, *pictura* and *poesis* were companionable sisters in the service of the poet's art; from the other, the word was the bulwark of the spirit against the carnal enticement of the image ... Nearly a hundred years later [this dilemma] can lead Milton, in *Samson Agonistes*, to write a 'blind' tragedy that culminates in the destruction of a theater."[96]

Since Milton compares himself to the Greek tragedians in his preface, *Samson Agonistes* is written *as though* for a Christian transposition of the Greek theater, as was, more simply, the Byzantine play *Christus Patiens*, which he cites. At the same time he is writing some decades after the iconoclastically effectuated Puritan

"Closing of the Theaters." His play captures this situational conflict by putting a blind figure at the center of a visual presentation that is only virtual, and by building his peripety heavily into the verbal music rather than into represented action. "Milton represents this internal dramatic peripety not in the action, but in the poetry of the play, and particularly in the rhythm, a tremendous poetic feat."[97]

At an earlier point the rise, and also the preeminence, of the miniaturist Nicholas Hilliard and other miniaturists, after forty years of iconoclasm in England, evidences not only secularization, because the miniatures are of dignitaries and of handsome young noblemen and -women. It also evidences a change in scale, not wholly to be divorced from the iconoclastic pressures—on the side of idolatry because the small object is precious like a jewel or the medal of a saint, and on the side of iconoclasm because the miniature's diminutive size subdued it into perspective with other sights in the environment, a less absorbing presence in the flow. The miniature can be held in the hand but is too large to be wholly encompassed, the way a jewel can be. These miniatures average approximately the size of the medals of Pisanello, which evidence something a little different, an intense ranging of possibilities through scale. Pisanello's medals suggest their availability to the hand but also suggest their heft; they would impose tactilely on the hand, and they "say" so, notably in the high bas-relief of their execution.

The interconnectedness of art and exchanged senses within a society tends to become more reticulated and subtle, rather than vanishing. And part of the reticulation for us is the hermeneutic assimilation of the interconnectedness, no longer strictly alien, that we somehow tap into when we at our different, present time and place construct, but also immerse ourselves in, the experience of the

shadow play, the Greek tragedy, Renaissance painting, tomb sculpture, mask, totem pole, or bronze head.

This very possibility of an assimilation of the art of other cultures is not open to them, since an Ashanti bronze caster or a Greek tragedian would presumably not know what to do with a Rembrandt. The possibility we have of crossing from one culture to another means that we have hypostatized the social interconnectedness into an art-function. Still, we have not wholly freed ourselves from the iconoclastic and idolatrous ambivalences, as is shown in our reaction to photographs. It means, further, that the ineffability of the artistic experience derives from its evocation of a sense of interconnectedness, a presence that is not nullified but rather subserved and enriched by the various absences and pressures that can be traced as functioning within it. This final sense of interconnectedness cannot be proved; such is its nature. The constructive yields to proof, the immersive only to description or characterization. And what corresponds to disverification in such an account as I have briefly given would be the counter-verification that, again, without some such procedure we would be at a loss to offer any substantive account of the value of the work of art.

The conditions bearing on the particular value systems can, of course, be characterized in various ways—as Kant's disinterested and pure teleology, as Dewey's "experience," as Heidegger's *Grund*. But such characterizations, including that of Heidegger, who bases himself on the principle of characterization or hermeneutic description, merely translate the artistic immersion into the terminology of a particular larger system.

Heidegger stresses the ubiquity of art in space, the public art of architecture. Then he leads, through what are inescapably

related questions, to the truth in art. "Art works are known to everyone. Works of building and of visual art are found on open squares, in churches, and in people's houses."[98] They are not simple things (*Dinge*), he says, though the visible ones, the works of visual art, are rooted in visible questions.[99]

Speaking of Van Gogh's painting of shoes, whether the shoes actually belonged to a peasant or the painter himself, he manages reflections that do hold: through the painting their instrumentality (*Zeug*) brings the viewer into the open of a deep perception of destiny—and with "dependability" (*Verlässlichkeit*, 30)—of the intersection of "earth" and "world", the deep ground of living (*Erde*) and our constructs about it and into it (*Welt*). "World grounds itself on earth and earth towers through world."[100] Thus is achieved in an art work a certain repose (*Ruhe*, 31), and this repose, it should be asserted, is a repose-in-space that engages the viewer in something more profound than mere appreciation (77). Thus through the art work, may it be said, does the "world world," "*Welt weltet*," in Heidegger's insistently circular intense summary of his process. "The instrument [thus] gives in its dependability its own necessity and nearness to this world."[101] The ensuing "rest" is the opposite of "movement" but rises out of movement (49), including the many motions of eye-assimilation and consciousness-processing that have their goal and resuming definition in the rest that rises out of these motions, "In the innerness of the struggle, therefore, does the rest of the work that reposes in the work have its essence."[102]

All this constitutes a "clearing" (*Lichtung*) in Heidegger's special sense, a "spatialized" opening into the laying-bare of the truth in the existent (56-57), "Beauty is a manner in which truth has its existence as unconcealment."[103] The resultant knowing is

also a willing, "The knowing that remains a willing and the willing that remains a knowing in the ec-static letting of the self of the existent man into the unconcealment of being."[104] Heidegger has managed the characterization of a primal time-sense, beyond periodization. And he has linked it to space, as an affective correlative to Kant's deductions about the a priori presence of time and space in a perceiving consciousness. As David Wellbery says, "philosophical discourse creates 'art' (the aesthetic) as its 'other,' as something radically different from and yet profoundly related to philosophical discourse itself."[105]

For the Heideggerian paradigm, as for any conceivable "aesthetics," a sense is arrived at only by going beyond "aesthetics" to larger questions of psychology and epistemology and metaphysics. This very fact may be taken as a further indication that it is such interconnectedness that the art object itself evokes, and in its own way hypostatizes, through its openness to immersion. Here the poem is not at all different from the painting, though it is endlessly instructive to look from poem or painting to the temporal or spatial, the lexical or syntactic, constituents of its makeup.

● Space always signifies in human society, down to the last inch. In cultures where the spatial demarcations are stark the face itself is painted, and the painted figures on it are mapped into structured significations.[106] Governing the space of an art work itself, sculpture or painting or architectural structure—or feathered headdress or festive bowl or hunting fetish—is the space in which a participant is conceived of as reacting to it and assimilating it, a look that cannot help selecting it from the environment and both matching it to

and contrasting it with the environment. This is splendidly illustrat-
ed in Boas's citation of an analysis of the decoration on Arapaho
moccasins that themselves at once add interpretations of both space
and time in the cosmos, from the feet up, and map it out decorative-
ly: "On an Arapaho moccasin the longitudinal stripe signifies the
path to destination. A small stripe at the heel of the moccasin signi-
fies the opposite idea, the place whence one has come. The variety
of color in the larger stripe represents a variety of things (which
naturally are of many different colors) that one desires to possess.
The small dark-blue rectangles are symbols that are called *hiteni*,
meaning 'life, abundance, food, prosperity, temporal blessings,
desire or hope for food, prayer for abundance or the things wished
for.' The white border of this moccasin ... represents snow. The fig-
ures in it represent hills with upright trees. The stripe over the
instep signifies 'up hill and down again' ... The dots in the stripe
represent places left bare by the melting snow."[107]

From the early middle ages on, the interior of a church
seems to have been conceived as a variable space, a space whose
walls could be covered at every angle with paintings. The panels of
these paintings might present a local order inside a given chapel, on
a spectrum of possibilities. Still, the life of one saint or a series of
Biblical scenes crowds up against that of another saint leaving, per-
haps, no intervening space as they lead into another area itself of
many angles, or into a stained glass window framing episodes from
the life of still another saint. Thus such churches as the cathedral
at San Gimignano, and spectacularly the Lower Basilica of San
Francesco in Assisi—and, with its randomly juxtaposed mosaics,
San Marco in Venice, where again local orders in the Baptistery and
elsewhere conform to no overall plan.

The True Cross series in San Francesco at Arezzo is on the central altar, and it dominates the church. Once Piero had placed his own panels in a central order, set so as to be not merely illustrative and not dependent on the main foregone story of Old and New Testament or the life of a particular saint, then the door was open for expansions of such order as Michelangelo's in the Sistine Chapel. Raphael might bend his attention to painterly prowess and stay with the miscellany of an old-fashioned random order in the large culmination of his work when he blocked out paintings for the rooms entrusted to him in the Vatican. Piero's principle of order, furthered by Michelangelo, could be stretched still later by Annibale Carracci when he filled up with a single conception the ceilings, but also the cornices and buttresses and arches he painted in the vault decoration of the Galleria in the Palazzo Farnese, solid paintings curving upward, interrupted by bust niches.

In religious series, from Giotto to Piero, the spectator is drawn increasingly into spatial activation. In Renaissance secular works, such series as Mantegna's Camera degli Sposi at Mantua, or Paolo Uccello's related battle scenes for a Medici chamber, expand into a private space. The secular space is pursued and redeemed by a psychologically oriented presentation of mythological scenes. These secular possibilities may have liberated the religious space of Michelangelo's Sistine Chapel, which includes the Classical Sibyls along with the Prophets. It is an expansion of the "human-sized" Piero's order, but also a return of its logic to the conventional Biblical history from the subjective elaborations of Piero's cycle. In the Sistine Chapel the worshipper-viewer is surrounded on all sides—and also, majestically, above his head. This expansiveness does not depend on a particular style of architecture and its symbo-

lizable coordinates. The late Byzantine Baptistery at Florence also led the worshipper to crane to a ceiling, as would much later ceiling frescoes in the grand spaces, sacred and secular, decorated by such as Tiepolo.

● The great strength of Rome, as of Egypt and Greece, found its spatial correlative in the imposing presence of large buildings. Vitruvius systematized this, and the self-consciousness of the Renaissance after Alberti and Palladio gave attention not only to planning new buildings on his principles but also to assessing the larger space into which buildings would fit, the plans of villa complexes and composite squares like Michelangelo's Campidoglio and the St. Peter's brought to its fullest organization by Bernini—and to whole ideal towns like Vigevano.[108] Palladio himself had written about existing buildings like the Pantheon; he is an architectural critic as well as an architectural systematizer.

In another disposition of space are the long corridors and huge pyramids of Egypt, a rectilinearity filled with symbols, dominating an emptiness. In Mayan temples, comparably, with their massive central masks on panels flanking stairways, all spaces are inescapably dense with significance.[109] Inescapably also rooted in the depth perceptions of that culture, they still reverberate in the attention of the modern viewer.

But attention to space is surely already emphasized from the strong internality and the seemingly elaborate demarcation of areas in the paleolithic caves, and then at every further phase of human existence. The outdoors, and distances too, figure in this phenomenological mapping. Landscapes haunt not only Roman

painting but ancient Greek painting back at least to the third millennium B.C., to judge from the already developed traditions shown in the second millennium frescoes at Thera (Santorini).[110]

Open air and hills figure notably in Piero's paintings. He adapts them in such impositions of faces on landscape as he emphasizes in the arresting diptych thought to be planned for the entrance hall of the Ducal Palace at Urbino. There the very large facing profiles of Federico da Montefeltro on one panel and that of his wife Battista Sforza on the other are both set against distant landscapes below them. On the back of each of these panels is an allegorical Triumph, also set against a distant landscape. The continuity between front and back is asserted by the continuation of a meandering river behind his Triumph and of riverless mountains and plains behind hers. The accessibility of spaces, their assimilability from nature into culture through utilization or worship, is celebrated in such structures as the Greek temple, blended into the space of its setting.[111]

● Space, to take one example, is a basic category of the Indonesian Village, and the principles on which it may be analyzed and subdivided is applicable to societies in general, as Pietro Scarduelli cites Lévi-Strauss for asserting:

> The ... category of "house" ... has come out as a symbolic structure, a microcosm which reproduces the image of the natural and social order ... in [an Indonesian village] the symbolic organization of the space is the main means used by natives to interpret their own social organization and to define social

identity. The symbolism of the space is not confined
to the house but extends to the whole village; neigh-
borhoods, ritual centers, mounds are different parts
of a conceptual network, an integrated system of
meanings.[112]

And the organization of space in communities is not just one-
dimensional but may involve several interlocking systems, as Lévi-
Strauss demonstrates for villages around the world—for the North
American Winnebago and the South American Bororo as well as for
villages in Micronesia and Indonesia.[113] As evidenced in the pre-
Columbian customs of Textopochlli, the spaces tend to be severely
demarcated and forcefully maintained; violation of incest taboos is
associated with the violation of spatial boundaries in a communi-
ty.[114]

The man-made environment of town or city is a humanly
interpreted space that evokes further interpretation, and ultimately
the transmutation of further architectural modification, in whole or
part. As Manfredo Tafuri says, "What suddenly comes clear is that
all this fractioning, twisting, multiplying, discomposing [of build-
ings], beyond the emotional reactions it may solicit, is nothing other
than a systematic critique of the *concept of place* with the instru-
ments of visual communication."[115] For Tafuri the city may evoke
both the sublime and the beautiful of Burke.[116] Cities offer a play
of movement and enclosure even across the "grand empty spaces"
they open into, from Rome, Berlin and Paris to Washington and
Peking, or the Benin City and Jericho of old. Domes, at the center of
a city or punctuating its skyline, mime the vault of the heavens, in
an ancient metaphoric association.[117] Avenues lead off to infinity.
Walls forbid but also partition, extending the city while subdividing

it and closing it off while making its space manageable. Both the openness and closedness of the square, as a microcosm of the city, come to a head in complexity and expansiveness. So Bernini's St. Peters. And so the quintessential square, evolved into its monumentality and accessibility through the accidents of time, San Marco in Venice. There cathedral abuts neighboring palace which faces out over water to other churches. Over the square itself is elevated the crocodile, and the gilt-bronze horses over the porch of the church. Higher over a balcony is the large clock, beside the towering, freestanding Campanile. Porticos, regular punctuations of darkness, demarcate the sides. All of it sweeps up, extends, and absorbs the immersed viewer.

Through architecture space stimulates and frames events; thus the city resists time while referring to it and enlisting it. At a certain point, Giedion tells us, there evolved the notion of the star-shaped city, with a central observer at a focal point. "The medieval city is characterized by expanding belts of streets; the Renaissance, by streets that radiate directly from the center."[118] It can be seen that Piero's *Ideal City* includes and transcends both types. Comparably multiplex is Michelangelo's handling of the Capitoline Square in Rome: piazza and stairway and city are there angled and combined.[119]

There is a tomb-like aspect of buildings: their fixity, solidity, and durability may make them take on the air of a cenotaph. Indeed the early cities in Babylon were intended just for worship and not for the rest of living. The ziggurats stood not at the center of the city but in a separate location, like the Etruscan necropolis. Hadrian's tomb assimilates comfortably to the rest of Rome, as does that empty monument, the Panthéon in Paris—not to mention the com-

plex of Les Invalides. The emptiness of Piero's *Ideal City*, again, has a mortuary air for its total lack of represented activity, by contrast with such only slightly later work as Gentile Bellini's *Piazza San Marco*.

The undulating wall, stressed by Giedion, opens into movement and sets interior and exterior into interaction. Piranesi jumbles external and internal because the process had already been suggested in the city around him. The galleries that were to develop in another century or so also somewhat erase the distinction between interior and exterior, and the use of glass in the nineteenth century and elsewhere, for galleries among other structures, carries further the melding of exterior and exterior. Giedion compares the Crystal Palace and such paintings of Turner's as *The Simplon Pass* (and not the views of Venice or other cities). "all materiality is blended into the atmosphere."[120]

In a still further development, the structural use of glass and steel leads to such conceptions as the *City of Light* of the Dadaists, an imaginary giant glass, as it were, to set beside the *Large Glass* of Duchamp, a see-through sculpture.

In the "Falling Water" of Frank Lloyd Wright a large private house is built towards the interpenetration of culture and nature, interior and exterior, in a harmony of forward thrusts and recessions. Since the Renaissance at least in the West, and in the Far East long before that, the planned garden has managed the space of a natural environment so as to communicate back to a person standing or moving in it a structured sense of nature, an interpenetration of nature and culture. The garden itself is based on a placid contradiction visually resolved. It grows up as nature, or else it plants the ungrowing, the stones of the Japanese or another gar-

den, among tended trees and flowers. But it has also been plotted
out, this way or another, as culture. Thus interwoven, nature and
culture combine to please and reassure. With such domestic archi-
tecture as "Falling Water," Wright transposed the planning of the
garden into the structure of the house. In the Oak Park house he
built his studio around a tree.

Still further, to take a single example, there are such tran-
spositions of inner and outer as the Engineering Building at the Uni-
versity of Leicester, as designed by James Stirling, in the analysis
of Peter Eisenman: "He ... produces a datum plane, as a fulcrum
element that implies not the original multi-volumetric conception
but rather a single box. The conception of the resultant box is nei-
ther a dematerialized object in the cubist sense nor a series of vol-
umes in the constructivist sense. Rather the actual boxes are con-
ceptually 'destroyed' and at the same time the virtual quality of a
single box is produced by the way the object itself is eroded" (9). "
... the brick and tile are presented in such a way that their respec-
tive load bearing and surface qualities, while apparently functional,
are often reversed; their *real* substance is suppressed for their real
value as a *metaphorical* substance." (10) ... "that which appears to
be the most ... solid ... are the windows" ... "reversal upon reversal
... we can read, simultaneously, literal void and conceptual solid"
(20).[121] All this has not parted company with the feeling of *The
Ideal City*, though of course the structures are very different. And
theory confronts what had arguably been the case since Francesco
di Giorgio (to whom *The Ideal City* has sometimes been attributed)
and Alberti. And a long period of practise will validate Stanley
Tigerman's assertion of the rapprochement and interdefinition of
text and architecture by practitioners, notably including Peter

Eisenman, and Jacques Derrida, who collaborated in the "Choral work" project at La Villette.[122]

● To move back to the art object itself, Cézanne forces the viewer to accept and align himself with an underlying geometricization of space that is at the same time dense on the surface. Cubism wrenches and multiplies this activation, and Cubist sculpture highlights the equivocalness of the distinction between three dimensions and two. Such a revisualization permits the layering-through of planes in Constructivist sculpture, while Henry Moore and Barbara Hepworth let space through post-Cubist rounded forms by setting holes in the solid surfaces, as does the Arp of the "Ptolemy" series. The mobiles of Alexander Calder and other kinetic sculptures add either random or recursively plotted time to such spatial openings.

There is a spatial wrenching, as well as a discovered shape-matching and an incipient metaphorization, in Picasso's head of a bull made of a bicycle seat and handlebars. The found object in itself is a reclaiming and a redefinition of lost space. The soup of objects in surrealist paintings like those of Miro or the soup of forms in non-objective paintings like those of Kandinsky opens an aerial and ideal space for the viewer, in which he can conjecture himself to be moving, exhilarated by an equivalent freedom. The impasto and swirl of a Jackson Pollock adds density to this set, as does the bold recombination of a Robert Rauschenberg. In some of Frank Auerbach's portraits and figure studies the impasto is so thick that it stretches and melts into the third dimension, fusing a questioning and an affirmation of light in space. In his *Large Glass* Marcel Duchamp adds transparency to a space in which abstract structur-

ings and arbitrary namings warped into a syntax commingle with the found objects. Huge size in the work of James Rosenquist and Anselm Kiefer stretches into a disorienting wonderment, unconnected as such work is to the social coordination of vast paintings like Veronese's *Marriage at Cana* or Géricault's *Raft of the Medusa*, which centers vast space on mortal sufferings. The setting of withdrawn, expansive leisure, the essence of the spirit of the villa, orients the largest of Monet's Paris and New York *Waterlilies*, which lie open before the viewer as they surround him in these broad works. So the Oceania cutouts of Matisse suggest by their largeness the freedom of an antipodal world. In the broad space of such cutouts even *The Swimming Pool* is angled so as to suggest the oceanic, as the *Dancers*, like the largest of the earlier *Dancers*, opens towards a cosmic space that suggests the metaphor of the dance of the universe in poets from Davies to Yeats. The largeness of Picasso's *Guernica* enlists spatial monumentality into an absorption in an explosion of totalitarian horror, or an implosion, as a strenuous openness implodes on a strangling enclosedness.

Bold chunkings edged into three-dimensionality enlarge the space of the paintings of Frank Stella. A post-Cubist stretching and enlargement in the paintings of Elizabeth Murray turns the work into a torqued object on the model of a Moebius strip or some kind of Borromean knot. It is as though Francis Bacon's post-Cubist deformations of the human face, tough and intricate, had been erected into a principle for inanimate nature. Further, the canvas is broken into segments, sometimes skewed and built up three-dimensionally, and made coterminous with the represented object it then ceases to frame. In these presentations Murray's enlarged coffee cup immobilizes and refuses to spill its splashing contents; the easel and brush-

es themselves bend round; a table rears under a Cubist dog and remains stable. Here interior and exterior trade off, and the seemingly fixed distinction between the object that surrounds (like the cave wall painting) and the object that can be held in the hand (like a small sculpture) is subverted. The stubborn cracks that angle between segments of these sculpturesque paintings remind and assert that space can enter at any point, and be commanded at any point: emptiness is an integer, just as is fullness.[123]

● There is a loss of perspective in the modern city. A corresponding dislocation of scale, always potential and sometimes actual, disorients what it now means to walk around a city. There is an unevenness and sprawl of horizontality and verticality that leads to a confusion, as well as an interchange, between interiority and exteriority.

 This situation of indeterminacy is exploited in the visual poetry of Jenny Holzer and other conceptual artists who invade the environment with often mobile and lit aphorisms, an invasion that is part of the signification and effect of such verbiage "out there," where it is not usually found. The private and instrumental mechanisms of print for language suddenly become physical and "out there," and without the referential setting of the advertising sign or the public celebratory banner. These self-contained poetic statements, projected into the environment, do thereby emphasize themselves as slogans—or "truisms," as Holzer calls them, though that term plays down the arresting quality of their inventiveness. As Norma Kassirer summarizes their challenge to, and assimilation in, various environments:

The electronic sign in Las Vegas...at the front of Caesar's Palace ... the statement "MONEY CREATES TASTE" vied strangely with the more commercial blandishments of that sea of flashing signage. Or you might have noticed that the lighted words moving around the baggage carrousel in the Las Vegas airport say "CHARISMA CAN BE FATAL" or perhaps "ABUSE OF POWER COMES AS NO SURPRISE." In Washington D.C. at Dupont Circle you could have read that "MURDER HAS ITS SEXUAL SIDE."

Kassirer goes on to summarize the Holzer aphorisms scattered through Venice well beyond the Pavilions of the 1990 Biennale, where she was featured. Her aphorisms were on stone benches, on posters and electronic signs, on the Vaporetto, and even printed on the back of Vaporetto tickets. "The movement of the electronic sign, Holzer says, is for her like the spoken word. The rolls and pauses possible with the technology are the kinetic equivalents of the voice."[124] But these moving words also minimalize and verbalize the cinematic effect, at the same time cannibalizing the poetic text. They are an implicit commentary on the architecture of their setting, a commentary both juxtaposed to and included in the architecture. Under such conditions the significations of the blazoned texts reside not only in the enlistment of verse-like shaped utterance to design, but in the strangeness of a placement that reshuffles interior and exterior to raise and potentially to solve a question of the relationship of such aphorism to such environments. If these aphorisms expand to capsule essays, the arrest of attention to read them in another context is also part of their effect. And that is enough;

characteristically they eschew the other devices of "concrete" poetry, the Calligrammes of Apollinaire and their successors. The plain, mobile message floats in the environment, all but subliminally, mingling with streets and buildings and clouds.

● Palace and garden parallel, and even imitate city in their handling of space. As Giedion says of Versailles, "for the first time, a great dwelling complex (equal to the small town in size) was placed in direct contact with nature ... A century later the pattern was adopted in town planning for a completely different social class in another country."[125]

This extends the villa, itself much elaborated in the Renaissance and led to interpenetrate with the spatial handling in paintings. Another century or so after Piero, and the perspectives of the viewer of sited paintings would be enlisted to open in another direction, down aisles that extend the view and confirm it on two sides, on four, and then to the distance.

Veronese makes this the case for his figures painted in Palladio's Villa Barbaro at Maser. There splendid secular figures are seen down two coulisses, left and right, on either side of the far walls of opposing rooms. One courtly figure appears at the end of an elegant chamber in one direction; the other, opposite, down his corridor on the far wall of another chamber. These chambers are to be seen from a hall between their four doors, at the juncture off a corridor of a central ogival hall which is itself topped by paintings of the pastoral seasons, while front and back the real view opens on the real, cultivated slopes of the selfsame hills.

In the vault, set out in an octagon, a pantheon of deities is disposed on clouds, beside Eternity seated on a winged dragon. In the pentagon beside the octagon are four deities symbolizing the four elememts. And on the lunettes under the vault, symbols of the seasons: Venus on the clouds with Vulcan and Cupid; Flora surrounded by nymphs; Ceres inclining toward Bacchus. In a neighboring room, allegorical beings: Faith, Charity, Strength, Truth, Virtue, Glory, Merit, History, and Time. And on the walls before the windows, Christian scenes: the Virgin feeding the Christ child and the mystic marriage of St. Catherine.

All these are powerful and delicate extensions of a proportionate structure provided by Palladio. This cruciform hall splits into the rectangular rooms, and then into the corridors. Veronese paints false marble columns, beams, niches, and cornice to frame his figures.

The seasons are pointed up in the "Hall of Bacchus" where Bacchus is depicted revealing to man the mystery of the grape. There one painted landscape gives through an aisle of trees to the central entrance of a more elaborate villa, and also one more old-fashioned than the Villa Barbaro itself.[126] On the first and second floor balconies of this painted villa stand figures diminished by distance,—a distance that the front of this villa blocks from going farther, while no fewer than four groups are scaled up the approaches: a man with three leashed dogs in the foreground; hard-on beyond him a carriage and horses attended by riders left and right, the left rider rearing laterally outlined; a man with horse, painted side-view, right, at the beginning of the garden; and another attended carriage, parked facing left, blocking the entrance to the villa.[127]

The effect is quite different from that of such cycles as Piero's. By its location in these exact but airy distances, our exalted body, as we face these Veroneses, is as though enlarged by having one ideal body visible at the end of a distance down through a room to our right and another such correspondingly to our left. The body comes into a visual realization both of its own singularity and of its membership in a society where any jarrings are referred back to the potentiality of harmony.[128] "Harmony" is in fact the allegorical title of one of the Veronese figures who oversees the cruciform salon nearby. Other figures there suggest the mystery of enclosed distance, like the little girl painted peeking through a *trompe-l'oeil* half-open door, or the mystery of distance in elevation, like the small group of observers painted looking over a *trompe-l'oeil* balcony. The real distances of the estate merge pleasure and utility in their visible, seasonally changing presences along the lines of the many views out windows and through the planned spacings of trees.

● Still another activation of spatial organization for the viewer comes grandly forward in the practise of Bernini. If we measure the intense gold color, the strong vertical thrust, and the breadth of the rays descending from heaven at the center of his St. Teresa in Santa Maria della Vittoria by the bent, ecstatic draped white marble body of the saint and the arrow-pointing nearly nude angel on the one hand, and on the other hand by the expanses of polychrome marble surrounding and framing her in the aedicula, then we have only begun to expand and also to focus our attention, since way above her directly overhead are painted the heavens. As her intensely crumpling body shows, she is arrested as straining into

motion, like the Laocoon. And, as Irving Lavin continually stresses, light itself is used as an important compositional element, first through the windows and then the burst of gold rays flooding down on her.[129] Well off to either side are the two balconies holding the cardinals, four each, from the Cornaro family, who are variously engaged in more relaxed, conventional religious and social activities. While she strains they converse. They are also set at angles where it would be impossible for them to see her—except for one, who is blocked by a pillar.[130]

The Baldinucci speak of "un bel composto" (a beautiful composite) of architecture, sculpture, and painting, and Lavin (79) indicates Bernini's attention to this as a goal. Behind the cardinals are the rounded arches and pillars of the interiors of larger churches, on both sides, at once extending and enclosing the composition.

Underneath is a bas-relief of *The Last Supper*, gilt bronze on a background of lapis lazuli. There are pilasters inside and around the niche. Front and forward below the Saint is a casket topped by a cross-bearing lamb, with angels at the top corners. There are circled skeletons (left praying, right gesturing) on the floor. An alabaster paneling indicates doors of death, but as Lavin says (139), resurrection is a predominant theme in the modelling of the space upwards.

A banderole is held by two angels at the apex of the chapel, inscribed "Nisi coelum creassem ob te solam crearem," "If I had not created heaven, I would create it for you alone." This phrase is recorded as having been spoken by Christ to Teresa, but it can be taken as meant for all mankind.[131] The thrust upwards activates space, and the strong interactions of space in the whole chapel remind us that Bernini participated in theatrical production for the

Barberini operas. "Into this fabric Bernini wove a second architectural framework adapted from the completely unified design ... two distinct realms ... interlock with one another" (85), "the chapel is to be viewed [from] the exact center of the crossing under the main dome of the church ... " (97), "From here, and only from here, the niches conjoin the realm of the deceased to the realm of the altar, and the chapel as a whole 'makes sense,' both optically and conceptually" (97-98). There are two discussion pairs and two isolated figures in each relief. The vault decorations lay forth scenes from her life private life, in proximity to the dove of holy spirit, cloud-borne angels. As Howard Hibbard says of the whole composition of the Cornaro chapel, "There the wall opens up to reveal an unnatural space framed by pairs of columns set ajar, as if some gigantic force had heaved open the curtain of wall and bent it toward us."[132]

● Bernini, as he centers on St. Theresa as well as elaborating her by other figures in the altar, dares to exhibit her in the full throes of an ecstasy that, since it is a bodily ecstasy, encompasses the sexual, in a visual presentation that does not suppress the erotic while recommending in its organization and focus the allegorical and the theological. Christ does not transfix this Bride of Christ, and so that allegory cannot oversimplify the picture. Rather, it is an angel who is on the point of doing so, aiming his spear. Christ appears below in the framed bas relief of the Last Supper, and some connection obtains between the Eucharist thus being instituted and any other experience that will be brought supremely into connection with the sacramental. (In a more ordinary way, of course, marriage itself is one of the seven sacraments.) St. Theresa herself, in her Commen-

tary on the Song of Songs, follows the usual theological path of nuancing Eros into allegory, and she does so, though quite sensitively, far more schematically than this Bernini does, who takes a passage from St. Theresa's autobiographical writings as a basis for the iconographically unique figure at the center of his altar. The heaviness here resides in the extremity of the bodily throes that the whole organizing presentation heavily spiritualizes. The gold rays fuse Eros and spirit, but they emanate from the heaven at the top of the altar. The ecclesiastics in the balconies on both sides must be involved in discussions directly or obliquely concerning theology, and so by implication the *memento mori* of the deaths' heads on the pavement in front. They must hold silence over the erotic psychology and physiology of the saint, whose own silence reaches the stress of a visual eloquence produced by Bernini.

Lacan elaborates such connections in the saint's posture in *Séminaire XX*, using her figure as the cover illustration for the volume.[133] In this formulation Lacan demonstrates that in every large communicative connection, and so within the space of the St. Theresa offered to us by Bernini, a dialectic obtains. For this connection between Eros and spirit his summary terms can be brought to bear: (sexualized) enjoyment (*la jouissance*), the Other (*l'Autre*), the sign (*le signe*) and love (*l'amour*).[134] The sign is the point of the angel's arrow, but also the crumpling enfolded body of St. Theresa, but also the gold rays. Their interconnections, and the interconnections with the other figures in the overall altar, spatialize this dialectic, locking and expanding love into a spiritual that includes the erotic. The Other is God, and for Lacan (who usually locates this other in the figure of the psychiatrist as he culminates and enables the circuit of dialectic revelation) the Other is also the figure within

the self of an other who comparably and correlatively keeps dialogue on a track that is as complicated, again as the relations among these entities that lead to, and here focus on, *la jouissance.* "A truth exists ... in every leap of a discourse over to another."[135] If in Lacan's terms the Other leads to the conception of unity, virtually in the sense of Parmenides (14-15), then the dialectic terms are provided by which St. Theresa's relation to God and our relation to Bernini's representation thereof partake of the same structure. Lacan, indeed, speaks of the "strict equivalence of topology and structure,"[136] "The signifier ... is to be structured in topological terms."[137] And —that is, in terms of the mathematics of space, which he would apply, perhaps too diagrammatically, to the significant enlistment of space in such an art work as this altar.

This elaborately plotted angle, as Luce Irigaray forcefully argues, is from the side of man rather than woman, and Lacan's analysis would have to be expanded into a still further dialectic to be integrated into an adequate view of sexuality.[138] St. Theresa herself, as she spiritualizes The Song of Songs, declares that woman takes "Let him kiss me with the kisses of his mouth" (Song of Songs, 1.1) differently from man.[139] And in this light the juxtaposition of the heedless cardinals and the rapt St. Theresa on Bernini's altar serves as a kind of negation of the iconography of Susanna and the Elders, which it faintly suggests. Her difference from them, her integral intensity along the arrow of the angel, and the interiority figured by her closed eyes, represent her transcendence as it is centering into her own reception of a full message that the dispersions of the whole altar are shown as falling short of.

The sexualized enjoyment that is *la jouissance* engages all the psychological mechanisms, Freud has maintained. So, necessari-

ly, Lacan has taught us, *la jouissance* engages all the communicative ones too. "Reality is approached with the instrumentalities of enjoyment," "la réalité est abordée avec les appareils de la jouissance" (52), and Bernini engages us forcefully not only to focus on this principle but to attend to its interconnections, included in the very gaps of space that figure the lapse of the ecclesiastics in their balconies from attention to St. Theresa. "The unconscious is the fact that being, when it speaks, enjoys, and ... wishes to know nothing more about it." "l'inconscient, c'est que l'être, en parlant, jouisse, et ... ne veuille rien en savoir de plus."[140] Lacan, who italicizes these words, puts them near the beginning of a chapter entitled "The Baroque," and without following his insistence on the mathematical validity of this identification, we can take his cue that the organization of space releases as well as diagrams not only a communicative act but, in such achieved instances, the underlying communicative structure. "Where there is being, there is the exigence of infinitude," he says.[141] These assertions can be accommodated to St. Theresa's sense of God's permeation of her space, and to Bernini's sense of that sense.

> There is a hole there, and this hole is called the Other ... the Other in so far as a place where speaking, to be deposited—pay attention to its resonances—founds truth, and with it the pact that supplements the non-existence of the sexual relation, in so far as it would be thought, thought thinkable to say it differently, and that discourse would not be reduced ... just to seeming.[142]

Diffusion, centering, broad division, and expansion are all brought to bear on this small-scale space for our perception, just as all of

these features cohere and strain together on the much vaster scale of another of the mature Bernini's projects, his most spectacular, the entire layout of Saint Peter's, where the spatial integrations of other architects, Bramante and Michelangelo and Sangallo, are further integrated and scaled.

Bernini rounds, undulates, twists and contraposes: that is his Baroque element. It operates spatially at the service of a reorientation of the viewer through disorientation, a transaction that can come about quite simply, as in the façade of San Andrea al Quirinale. As critics have pointed out, he makes this wedged space seem larger than it is by juxtaposing the curved sides to the plain, but deeply recessed, front. Contracted, it expands; expanded, it contracts, and without *trompe l'oeil* effects. As a part of such interactive adjustments it realigns and vivifies the whole of the viewer's space, and he or she participates in an exaltation, just as happens through the regularity and smoothness of the plain, proportionally fenestrated buildings of Adrian Stokes' Quattro Cento, whose effect is at once dreamy and severe.

In the small as in the large Bernini qualifies the meanings in his spaces, as well as collapsing and expanding them. The Piazza Navona is both elongated and triply centered around three Bernini fountains of unsymmetrical elaboration, each a focus in itself, forming no allegorical whole and arrayed against moderately undistinguished buildings. Setting an obelisk atop an elephant, as in the Piazza of Santa Maria sopra Minerva, melds two precise images of Africa, and of culture and nature, as well as the "mobilized" immobile (the obelisk) and the "immobilized" mobile (the elephant). These themselves exact a contrast, since in the case of the elephant its motion is frozen by art and in the case of the obelisk its motion

is released by its artistically engineered position: and elephants never really move vertical obelisks. The elephant, indeed, in real life lumbers surely and powerfully forward. The only motion of the obelisk is that of the conceiving eye, pointed not forward but distinctly upward by the narrowing of the obelisk, as also by the effort, usually virtual, to read the hieroglyphics on its face.

On the tomb of Alexander the Seventh in St. Peters, the gilt skeleton of death, feathers strangely shedding from him, is enfolded in the sharply bent marble draperies, holding determinedly forward his hourglass. These draperies are held up by two women who round out and expand the space, one resting her foot on the "total" space of the globe while the other embraces a huge infant.

This tomb, like the nearby height-stretching baldaquin, punctuates the larger space itself defined by Bernini, the space of St. Peter's, combining the vast containment of the Square with the clearly regular (pillar-marked) vanishing parallels of the approach, the Square itself combining the arm-rounding colonnade with the rectangular square. And inside putti and medallions qualify the space of pillars which rise from a floor itself laid out in geometric circles and trapezoids. As Lavin says (20), the baldachin itself of St. Peter's is a "summa of the three main traditional forms of honorific covering: the architectural ciborium supported on columns, the processional baldachin carried on staves, and the canopy suspended from above." "the visual conflict between the closed physical nature of the vault and the depth requirements of illusion; and the conceptual discrepancy between the single space-time required for dramatic unity and the disparate space-times required for narrative illustration. ... in reconciling ... [he made] the vault itself serve both as the carrier of narrative and as the substructure for a unified illusion; the *tertium quid* in linking the two was molded painted stucco."

● The door is a space in itself. But it is also a threshold between two spaces, enlisted differently by different artists. The door starts plain, something to be got through, at best the planned compositional feature of an architectural ensemble. In medieval and Renaissance Portugal it picks up huge bosses or diamantine wedges, features of defense converted to ornament. A door will also take on scenes of what lies ahead, inside a church, religious scenes sculpted on the door that leads from the secular outdoors to the sacred interior, which the scenes on the door introduce and anticipate. In the hands of someone like Ghiberti these scenes become exquisitely wrought and finely detailed, arresting the attention still further. A glass door is a space to look through; it offers an illusion of emptiness, an actual danger for birds—and for people.

The plain, aged, heavy wooden door that Marcel Duchamp transposes from a Spanish village to the nearly opaque front, a frame for peepholes, to his *Etant données*, does homage to the rootedness and plainness of the village while forcing the viewer to be a voyeur, and also an exhibitionist who shows his voyeurism to himself and others—thus wrapping together these two slightly opprobrious activities as Freud does in his theory.

Again, in our own world, as an antithesis to the rounded, placed, and modulated evocations of bodies in Piero's organized frescoes one might further adduce this last work of Marcel Duchamp, *Etant donnés: 1) la chute d'eau, 2) le gaz d'éclairage*, in which the title contains an evasion comparable to the metonymizing elision of the Cross in Piero's cycle: the nude who is not mentioned dominates the assemblage. Duchamp's viewer, instead of standing squarely in

the middle and in a posture with devotional analogues, is forced to find the random hole in an old door and then to glue his eye fixedly on it in order to see at all. The head so poised, the body is as though blacked out while he or she contemplates the nude body in the pastoral setting of the assemblage that he can see so long as he remains so immobilized.[143] In this range the freedom of Duchamp entails an immobilization of the viewer, while the complex fixities of the codes of space and time that Piero manipulates provides a large space in which the viewer can move and breathe. Centralization becomes a form of idealizing empowerment.

The mirror itself, with a splendid lucidity, activates, and cannot help activating (but can be energetically helped by the painter to activate) a spatial dialogue of exclusion-inclusion and self-other, as well as of make-believe versus real and original versus reflection. The mirror itself, for initially spatial reasons, broaches the uncanny.[144] The nineteenth century practice of panoramic painting, the projection on all sides of a room of related scenes, as though they were a scene in the midst of which the viewer takes his stand, completes, fixes, but also oversimplifies the viewer's space. The wraparound allows his gaze to go around a circle, or to change direction, as in the city, relaxing it from the dialectic of participatory space that Michael Fried finds in the act of looking at such a focussed work as a Courbet and that is already present, mutatis mutandis, in the inner cella of the Erechtheum at the Parthenon, as inside the Parthenon itself, and also in semi-surrounding panel series like those of Piero's True Cross cycle. For our time the dialectic is given a further turn in works like Lukas Samaras' mirror room, where a table and a chair faced wholly with mirrors stand with a viewer or two in a room whose walls, ceiling, and floor are

wholly faced with segmented mirrors, repeating thus both himself or themselves and their surfaces into a multiply multiplied distance. At another angle are the works of Pistoletto, where photograph-like nearly full-size two-dimensional figures are attached to the surface of a mirror to join the viewer who is reflected next to them.

● All of this interaction and assimilation take place in the silence of space. If we add voice to the equation, we enter the realm of the theater, of opera, and of film, domains which offer thereby more complex configurations and also a plenitude that is forced to heal the rift between these two forms of plenitude, sound and sight. Adrian Stokes has argued that our sense of satisfaction in a purely spatial plenitude derives from a reattachment of consciousness to what it remembers from the good breast of the mother. But as Keith Cohen has forcefully maintained, since the infant's first experiences are of sound, not sight (if not smell), in artistic experience (he is writing about film) there is a built-in disparity between the two.[145] And this disparity would obtain of the psychic memory, as well as of the different primacy of time for sound and space for sight, and all the post-Lessing qualifications we can make thereof. As Cohen puts it, "Sound opens the possibility for the narcissistic regression to a virtually prenatal experience of union with the mother ... sound 'smooths out' our sense of the body, rendering it homogeneous and, paradoxically, less material." He goes on to analyze the primary pleasure that "resides in the conjunction of sound and image" A strategy is called for to effectuate the "bliss" of the spectator and auditor, the more that sound and sight are both genetically and perceptually disjoined. With sight alone, an absence takes

over, an absence that the artist makes stand for a presence through the coherence of its completeness. For in the visual arts, in painting and architecture and others, the bliss must be achieved in the absence of the reassuring and enveloping voice. The viewer must attune to the voices of silence, and the unitariness of his perceptions constructs a sort of substitute for the stereophonic (or stereoscopic) fullness of image plus sound. A comparable, reverse process obtains of the sequential naming and construction of images in poems, but that is another story.

● The theater resembles the mirror in doubling into a virtual space the space already totally mapped by the society. Specular and theatrical, painting enlists and implies the body of the spectator, as do the manipulations of architecture—garden and square and building. They provide an actual space that for having been culturally mapped and motivated is also virtual space. For the theater that virtual space has been analogous to or has variously involved religious worship and also religious areas. Not only in Greece but early in Italy at Gabii and Praeneste the theater precincts were hard by the temple. The religious association shows in various positive ways, and negatively in the restrictions and bans imposed on the theater. The theater in the West, of course, rose out of performances at religious festivals; long after the theater had become an independent institution formal processions were retained on stage.[146] The frontality of a procession, organizes and modifies the circularity of theater in a way reminiscent not only of religious celebration but of a painting.

The movement of live bodies before the spectator takes on a regularity that can approximate dance, as once the theater rose in conjunction with dance: the Greek theater space was originally a dancing place. The manipulation of scale and timing by a dramatist like Robert Wilson once again approaches and enlists the rhythmed motion of dance, even at its slowest.[147] Wilson began as a visual artist, planning and executing environments. Correlatively he expands and modulates the space of the theater, the most recent in a line of theoretical redesigners of the theatrical space that began with Gordon Craig and Adolf Appia early in this century. Wilson makes the space of the stage area yield the depth of a painting or a sculpture, and in it the images thrust themselves forward for prominence, while words and a version of plot recede to contributory status. In this he offers a mix akin to that of a film, but the inclusion of stretches of film in *The CIVIL WarS* highlights the difference; there the film is quoted as another image, one that happens to admit of speed, much the way the film itself may quote a still photograph. Some of these film sequences, of a children's lesson or a meeting, in montage with the stage and its action, establish what we already know, the norm of ordinary human motion against the stylizations of rhythmed change in the stage action. Other film sequences show sea creatures, or amphibious ones like the polar bear. They move through a different element, turbulent water, from the air of the stage, at a different speed, in a fluidity natural to the animal but beyond human capacity, at a different angle from the horizontality or verticality normal to humans, and all by creatures that seem gigantic, both for their actual size and for the filmed closeup of the projected footage. To quote film echoes differently from entering into the spatial set of a film. And Wilson's dance-like

rhythms, or the glacial slowness which reduces them in favor of an
image that is almost still, re-frame the image and call attention to
the entire stage set because that is predominantly what faces the
viewer. In film, Deleuze asserts, as in *The Fall of the House of Ush-
er*, the slow motion broaches an awareness of the essence of move-
ment.[148] Wilson's slowness points at the essence of rest.

 Slowness is notable in the last scene of *King Lear*. There the
slowness, by approaching the stillness of the object in space, evokes
something akin to that stillness: the body of Cordelia is not only
present but lifted as an object and verified as immobile, as the body
of Hermione at the end of *A Winter's Tale* goes into motion at the
seeming instigation of music. It is noteworthy that this is the point
where Shakespeare, for the only time in his work, mentions a paint-
er by name, Giulio Romano, whom he praises for representational
accuracy, a standard to which the painter-sculptor who produced
this "statue" of Hermione is fictively and momentarily compared.

● As Hamlet says in *Hamlet*,"I could be bounded in a nutshell/
and count myself a king of infinite space." (*Hamlet,* 2.2.251-252.)
This principle, seized and grasped in the imagined words of a pres-
sured Hamlet, opens a theatricality of others fed back into them-
selves in a space that admits of such characterization—and corre-
spondingly of such movement. In the words of the Chorus of *Henry
V*, the space is a "wooden O" that invokes a "Muse of fire" to help
it "cram"—while such contraction ("bounded in a nutshell") allows
for a complementary, and in this dialectic not a contradictory,
ascension ("infinite space") for the "swelling scene":

O for a Muse of fire, that would ascend

The brightest heaven of invention,
A kingdom for a stage, princes to act
And monarchs to behold the swelling scene!
　　　…can this cockpit hold
The vasty fields of France? or may we cram
Within this wooden O the very casques
That did affright the air at Agincourt?

These gestures do admit the "vasty" in their compass. Their sub-version of the unities of space, time, and action, much discussed in the theory of earlier Continental critics like Scaliger, does not simply open up the classical tightness for a larger and freer, a more panoramic dramatic presentation. It raises the conception of space to an exponential power for the engaged auditor, carrying through the ranging spaces of the play.

Their continual changes vivify and expand the action, till the last act, which begins in a new, increasingly foreshadowed and fore-shadowing space, the graveyard, where the arrival of Ophelia's funeral cortège brings a convergence of all involved to the one spot. They pass into the great hall to take up and conclude their counter-purposes in this enclosed space, and to die, as Fortinbras comes in from his long, now revealed expedition to take over the kingdom. He gives a volley to announce—Ambassadors from England (!) (5.2.340), who themselves arrive and speak, closing the circle of three kingdoms.

The preparations for the final duel traverse a spatial range from the pearl ("union") in the toasting cup to the heavens receiving the echoing music:

And in the cup an union shall he throw,

Richer than that which four successive kings
In Denmark's crown have worn. Give me the cups;
And let the kettle to the trumpet speak,
The trumpet to the cannoneer without,
The cannons to the heavens, the heavens to earth,
'Now the king drinks to Hamlet!' ...

 5.2.261-267

The spatial range is sustained by the king's hyperbole, but only for an illusory moment. The whole collapses before the deep duplicity of this pseudo-celebration.

● In the *Oresteia* there lingers a possibility of a connection in the life of Aeschylus between drama and not only, as always in Greece, religion, but specifically the mysteries of the Eleusis of his origins. This possibility at once sets up the idea of an essential space, that of initiation, from which all other spaces may take definition; and thereby the opening of the *Oresteia* presses these bounds of the Greek world to its limit, and visibly. The actual place of dramatic performance is in the open air, and very spacious, as Thomas Rosenmeyer reminds us, "The stage on which the Aeschylean chorus and actors mingle is a hard-packed circular dancing floor ... some eighty feet in diameter, and thus more than half the width of an American football field."[149] The watchman evokes the stars of the heavens as he stands on the open space of the roof. He reports, as the first play begins, on picking up the signals that have been relayed from mountaintop to mountaintop across seas all the way from the Troad in the Northeast past the Athens of the play's performance to the Argos of the play's action to the southwest.

The chorus dwells on the torches "through the length of heaven" (92). At the end of the last play in the trilogy, the Furies, now "reverend goddesses," join the torchlight procession of the group of women and the band of youths. Athene, in her resolving speech, "will lead with the light of the flame-bearing torches/ to those places beneath and under the earth." (1022-23). The otherness of space has been evoked, stretched, maintained, and internalized to express and celebrate a possible depth of perception within enigmas of resolution.

● As Erwin Panofsky said of film, "These unique and specific possibilities can be defined as *dynamization of space* and, accordingly, *spatialization of time*." [Italics Panofsky's.][150] But this is only a beginning definition, and it admits of the vast permutations offered by many theorists, notably and recently in the two volumes that Gilles Deleuze has evolved, building on Bergson's analyses of the psychology of motion in time. As Deleuze says, elaborating his categories, "The movement-image has two sides, one in relation to objects whose relative position it varies, the other in relation to a whole—of which it expresses an absolute change. The positions are in space, but the whole that changes is in time. If the movement-image is assimilated to the shot, we call framing the first facet of the shot turned towards objects, and montage the other facet turned towards the whole."[151] Hence, long ago, Eisenstein's stress on montage, and on the "contrapuntal method of combining the visual and aural images."[152] On the negative side there is the persistent reminder of Christian Metz that the frame of a single shot forms a whole as a complex signifier and cannot be broken down into seman-

157

tic constituents along the lines of a language.[153] And on the positive side there is the rich combinatory vocabulary of Deleuze, which he keeps expanding, "we find ourselves faced with six types of perceptible visible images that we see, not three: *perception-image*, *affection-image*, *impulse-image* (intermediates between affection and action), *action-image*, *reflection-image* (intermediate between action and relation), *relation-image*."[154]

The camera is a relatively mute instrument. The dialogue of characters in a film has got to be kept fairly simple, and so the camera may never get to the point where it can provide room for its accompanying spoken text to parallel the verbal complexity of Kafka or Proust, or for that matter the complexities of its interaction of images as expanded on by Deleuze. Film relies on the interactive sounds of words and also music, but it relies even more on the composition and sequence of images, on shots and on montage. Montage itself, as a sequencing of space, dominates the film, as commentators from Eisenstein and Pudovkin to Deleuze have shown. The artificial patterning of montage amounts to an emotional shorthand, one that may be composed of a documentary richness but is nonetheless composed of images like a painting, just as the individual shots are.

Moreover, images shown successively on the screen may not have happened successively in life. There are conventions for suggesting a normal succession from past into present, like a rapidly peeling calendar, and for suggesting the movement from present into past, like the flashback or "fadeout" shot used to indicate memory. But the camera can also conceal the temporal sequence. Further, it can conceal the location of its images in reality. Consequently its temporal sequence and the convention of its projection in

a darkened room remove from it the coordinates of the photograph, which typically cues the viewer to its location, and to the reality of what it has mounted; the dream photograph, the surrealist montage or collage, are obviously imaginary on the face of it. But what we see on the screen may be an actual happening, or it may be a thought of the character; and that thought may be memory or fantasy. Detective films use this feature of indeterminacy for trickery, sometimes very skillfully, like Hitchcock.[155]

In *Last Year in Marienbad* Alain Robbe-Grillet and Alain Resnais play present against past and fact against memory or fantasy to produce a well-tempered clavichord of the techniques that may be combined by montage, opening up thereby a labyrinth of consciousness and affection more systematically and exuberantly than in the novels of Robbe-Grillet, where the primacy of the verbal means and its confinement to documentary obsession combines with the laconic suppression of statements about fact and emotion to produce a series of puzzles. At their extreme angle these evade identifications of fact, not allowing them to permute into the visual. As Gilles Deleuze says of film generally, "the frame assures a deterritorialization of the image."[156] In the novels the visual is evasive evidence; in this film it is an integer of combination.[157]

As commonly in films, the actual Palace of Nymphenburg stands in for the health spa that at the time of the making of the film could not have served for so luxurious and free-floating a flirtation. That present, the actual Marienbad in a Communist Czechoslovakia, could not have given a spatial location to that past; both present and past are thus suspended in the honorific presentation of a luxurious and vaguely regal backdrop, associated to neither the present of that (or another) health resort nor caught up in the inter-

actions of some remote version of Versailles, where noble presences would have preempted far more of the action, if verisimilitude were in question rather than dream permutations of verisimilitude.

Film is a visual art, though a temporal one, and it enlists analogues to Cubist, surrealist, and illusionist procedures in painting. Eisenstein cites both Picasso's *Guernica* and Piranesi. Film substitutes exclusion in darkness for the arrest of looking at an immobile painting or sculpture. In the darkness, suspended from the environment, the pure flow of the film's sequences does duty for the clean structural components of other visual work. It is not like theater, because it is only as localized as it makes the individual shots, and they open up the vision and the point of reference as they move on. So the cinematographer Vertov's "Man with a Camera," though documentary in a sense, retains some difference from the photographer, as Deleuze distinguishes the two. "For Vertov the photogram is not a simple return to the photo: if it belongs to cinema, it is because of the genetic element in the image, or the differential element of movement. It does not 'terminate' the movement without being at the same time the principle of its acceleration, its slowing, its variation."[158] And as Rudolf Arnheim says, of the still photograph inserted in a film, "A still photograph inserted in the middle of a moving film gives a very curious sensation; chiefly because the time character of the moving shots is carried over to the still picture, which therefore looks uncannily petrified. An ordinary photograph hardly ever gives the impression of rigid standstill."[159] The bodies, active on stage in the theater, are dematerialized in the film. As sequential, the experience of the film resembles reading, and also in its simulation through darkness of the solitude and interiority of the reading act. The "out there" is etherealized,

and in its suspension it absorbs an instrumentality like that of print. Its texture becomes incidental, whereas texture is always a constituent feature of a painting or a sculpture. These film images have the immateriality of pages with respect to what they con- vey—though the modern artist can take segments of actual film and turn them into collages or other images, the way he can take seg- ments of a musical score which, as a musical score, is a mere aid to producing the essential notes. And on the other hand, the modern anthropologist, or film-maker turned anthropologist like Louis Malle and Werner Herzog, may choose to confine the film to rich tran- sphotographic documentary.

● In the apprehension of the presence of others, and usually their bodily presence, or else of an empty, ordered space rendered figural, as in a landscape or a still life, we come to the sense and validation of ourselves. This principle has been stressed by philosophers, and by such psychologists as Lacan. This takes place, however, through the sound of language, in the apprehension of voices that "bethou" one another. If the voice is subtracted, the consciousness still fills in the gap. Like the apprehension of bodies in a painting, the sense of others is constructed from cues that can be decoded, but it also is immersive. We "bethou" them; we are at one with them.

We cannot exactly "bethou" a painting or a sculpture because in initial reality it is only a physical object, and it carries off the majesty of an inviolable silence. After we have brought our constructive skills to bear upon a painting, however, we can immerse ourselves in it, stably, without the flow of interruptions that social converse gives us.

In looking at the painting we are figuratively dealing with others but actually dealing with ourselves, anchoring and integrating our selves in that virtual experience, which constructive and immersive have hinged together to produce; perspective is constructive—but also immersive if we let the eye follow the vanishing points. Color is immersive in its directive presence, but also constructive as it variously codes symbols, and also as it plays off against other colors.[160] This strangeness of bodies that are there and not there to be dwelt on has aroused superstitions in many cultures, and iconoclastic caveats arise easily against the implied idolatry of representing the human image.

But, to adapt Lacan's categories, the painted bodies cut across all three of his functions: they are "imaginary," they are not there; they are "symbolic"; they enlist the whole interactive code, through the absent painter, on which our language and our reactions are based. Finally our experience with them, and therefore they themselves, are "real," in spite of Lacan's radical skepticism about the accessibility of the real. It is finally their reality that buoys us up, reassures us, and validates our experience of them.

In so doing they seal us in and open us up to larger integrations that our being in the space of the world would otherwise provide for us, while at the same time intensifying and interpreting that space and our positions in it, moving against their recapitulative stillness and finding a rest as against whatever turbulence and darkness they envisage. The offering is one of joy, either directly in the elations of form and color or indirectly in the organizations that lead us back to assurance, momentary but definite. Through such means the aesthetic gestures signify a larger realm than their own confinements, of space and means, would seem to allow. The

enlargement comes about through the very confinements; and thus, through the doublings of art, space expands itself through the meaning of space.

163

NOTES

1 For this extensive thirteenth century text, see J.G.T. Graesse, ed., Jacobus de Voragine, *Legenda Aurea,* Osnabruck: Zeller, 1965; William Caxton, tr., *The Golden Legend, or, Lives of the Saints,* London: Dent, 1900.

2 All three cycles, though, since the Church at Arezzo is named for St. Francis, can be related to two especially important Franciscan feasts, the Finding of the Cross on May 3 and the Exaltation of the Cross on September 14. Marilyn Aronberg Lavin points this out in "Computers and Art History: Piero della Francesca and the Problem of Visual Order," *New Literary History,* 20, 2, Winter 1989, 483-504.

Furthermore, Agnolo Gaddi's sequence is stiffer, in far more distant focus than Piero's, and gives far greater preponderance to the traditional architectural settings in which his panels are shown: (1) the Death of Adam (2) the Adoration and Burial of the Wood (3) The Wood Being Pulled from the Piscina; the Making of the Cross (4) St Helena Restoring the Cross to Jerusalem (5) the Flight of Chosroes (6) Chosroes Worshipped by His Subjects; the Dream of Heraclius; the Defeat of the Sons of Chosroes (7) The Beheading of Chosroes; the Angel Appearing to

Heraclius; the Entry of Heraclius into Jerusalem. Assuming that Piero would have examined these frescoes as surely as he would have Masaccio's in the Brancacci Chapel, then his departure from them is as remarkable as his (inevitable) echo of some of their themes. Solomon and Constantine, who bulk large in his cycle, are almost totally absent from Gaddi's, which concentrates on the conclusion of the legend, the victory and triumph of Heraclius.

An earlier, simpler representation still in Piero's geographical orbit is the series of six scenes from the history of the True Cross, done in 1215 for the Cloister at Berardegna and now in the Pinacoteca at Siena—nearly the earliest painting extant from Siena. For other differences between Piero and Gaddi see Michael I. Podro, *Piero della Francesca's Legend of the True Cross*, Edinburgh: University of Newcastle-upon-Tyne, 1974.

The Stavelot Triptych (1140) in the Morgan Library, an elaborate gold reliquary, concentrates on Constantine and Maxentius, and sets up the True Cross story as on an altarpiece. The "Dream of Constantine" is also included. Three bishops test the Cross by applying it to a dead man. The "Judas" is threatened with fire, not water. (Perhaps the well of Piero's version echoes and displaces the Baptism of Constantine motif, used here.) (William Voelkle, *The Stavelot Triptych; Mosan Art and the Legend of the True Cross*, New York: The Pierpont Morgan Library, 1980.) It can be argued that for Constantine as for Heraclius the Meeting of East and West is a theme also here—and this early; and so in the Arezzo frescoes it cannot be taken for just a reflection, as Charles de Tolnay ("Conceptions religieuses dans la peinture de Piero della Francesca," *Arte Antica e Moderna*, XXIII, July/August 1963, 205-241) and others suggest. *The Flagellation*

may, however, include a reference to the union of East and West, along with much else. The attack on Constantinople was imminent, and the words "convenerunt in unum" could be read on this painting up to the last century. Of course the Stavelot Triptych cannot, as a reliquary, enlist space in any of the more spectacular Byzantine ways. Thematically it concentrates on Constantine and Helena, as one might expect from a Byzantine-influenced work. And at its central panels are a crucifix and saints, the conventional icons of devotion.

3 Indeed, the tradition can be carried back very far, to related Mycenean and Minoan wall painting. For Rome, as Eleanor Leach describes Villa Oplontis at Torre Annunziata near Pompeii (Eleanor Winsor Leach, *The Rhetoric of Space: Literary and Artistic Representations of Landscape in Republican and Augustan Rome,* Princeton: Princeton University Press, 1988, 96), "Each of the five painted rooms comprising the Republican core of this villa contains some form of landscape representation ... While some landscapes are centered within vertical panels forming part of the surface ornamentation of a closed wall, others are framed by window-like apertures that have the illusion of being cut through the structural fabric of the wall. The colors and pictorial techniques of the landscapes differ according to their situations in context."

4 So Lavin reads it. As she goes on to interpret, "The unity here is that between the Old Testament, Christ's incarnation, and the world of Christian history. In using the festival arrangement with straight line vertical, Piero differentiated history from liturgy; the right wall concerns only history, while the left concerns

liturgy with the two festivals put together"(500). The complexity of Piero's conception, and also the very simplicity of his visual confrontations, are further highlighted if we notice that Lavin's oppositions are themselves susceptible of considerable modification, since liturgy cannot be disengaged from any of these panels, except as a distantly sponsoring occasion of festivals celebrating the Cross; and history here merges with legend, Sheba on a par with Heraclius, except in the overall pattern from the beginning of history with Adam to a cutoff point somewhat arbitrarily (for history, not for legend) located in the Byzantine period.

[5] Marilyn Lavin, *The Place of Narrative: Mural Decoration in Italian Churches 431-1600*, Chicago: University of Chicago Press, 1990. In her book she expands her categories of arrangement to eleven (4-11): Double Parallel; Wraparound; Counterclockwise Wraparound; Apse pattern, down; Apse pattern, up; Cat's Cradle, horizontal; Cat's Cradle, vertical; Boustrephedon, aerial; Boustrephedon, linear; Straight-Line Vertical; and Up-Down, Down-Up. She discusses Piero's arrangement especially at 188-191 and 284-286. Lavin says that the task of explaining his arrangement at Arezzo had started her out on her whole vast quest.

[6] Erwin Panofsky's essay on the philosophical implications of perspective connects these techniques to structures of thought as well as to modes of seeing. (Erwin Panofsky, "Perspective as Symbolic Form," 1940, translated from *Vorträge der Bibliothek Warburg, 1924-25*).

[7] The two versions, under normal light and under ultraviolet light, are reproduced in the detail of Jacqueline and Maurice Guillaud,

Piero della Francesca: Poet of Form, New York: Potter, 1988, "Commentaries," No. 3, n.p.

[8] *Aurea Legenda,* Chapter LXVIII, 303-311.

[9] Ibid., Chapter CXXXVII, 605-611, "De exaltatione sanctae crucis."

[10] Jonathan Goldberg puts this aspect of the sequence well in his "Quattrocento Dematerialization: Some Paradoxes in a Conceptual Art," *Journal of Aesthetics and Art Criticism,* XXXV:2 (Winter 1976), 153-168 (162):

> ... the viewer is asked to recognize, as the figures in San Francesco do, that the wood of the cross is everpresent and yet eternally hidden. Piero's paintings combine, paradoxically, immanence and transcendence, clarity and obscurity, revelation and mystery; in the *Dream of Constantine,* the union of revelation with sleep, of illumination with darkness suggests, if only by analogy, what Piero aims for: the underlying invisible form that his art strives to represent and contain. Piero's paintings, visible demonstrations of the recurrence of suprapersonal forms in the world, lead the eye through geometric forms to the Cusean recognition that mathematics remains an analogy—the best the mind can make—for the mystery of the relationship between appearance and spiritual reality and the relationship between sight and vision. Ultimately, in Piero, the very qualities that at first lead the viewer to believe

that he is being offered a way of seeing become the tools as well for visionary experience.

11 John White's analysis, in *The Birth and Rebirth of Pictorial Space*, Cambridge: Harvard University Press, 1987 (3rd edition), 196-197, is as follows:

> This majestic marble framing is painted as if it were seen from below, but in itself has a double function. The bases of the columns converge to a point about a foot below the lower border. The devout are once more looking up towards an extension of reality. The capitals, meanwhile, converge into the body of the Rising Christ ... The sarcophagus is in pure elevation, the pricked outline showing that the foot of Christ rests absolutely level on its rim. Similarly there is no foreshortening in the body or the head of the figure of Christ. Within the picture the whole question of the viewpoint is laid aside as unimportant by the very artist who, for the first time, produced a through-going application of the laws of artificial perspective...The soldiers form a circle set in space, and a pyramid centering in the head of Christ. They create a triangle upon the surface, or are part of a diagonal cross in space that runs into the distance with the trees.

12 Millard Meiss, *The Painter's Choice; Problems in the Interpretation of Renaissance Art*, New York et al.: Harper & Row, 1976, 63-82. And as Meiss says (66):

> Masaccio was probably familiar with a few

large-scale rounded compositions painted in the earlier fifteenth century. Two or three shallow examples by Lorenzo Monaco were visible in Florence, and a more highly developed design in the altarpiece by Gentile da Fabriano that was set up in that city in 1423. The composition of the main field, an Adoration of the Magi, is, like Lorenzo Monaco's representation of the same subject now in the Uffizi, based on two semicircles or ellipses, one behind and above the other. But in this instance, as in other paintings of the time, the curve is the reverse of Masaccio's. Tangent to the picture plane, the arc curls back into space at both sides; indeed, in this period before the introduction of systematic perspective, the space is largely created by the overlapping and diminution of the figures in these convex arcs. This "Late gothic" design, as we may call it, was still preserved in the thirties in some of the reliefs of Ghiberti and in the early work of Domenico Veneziano. It is inherently centrifugal whereas Masaccio's inverted form is decisively centripetal.

In this respect the *Tribute Money* was anticipated by the composition of a painter who impressed Masaccio deeply, Giotto. In the *Last Judgment* in the Arena Chapel Christ hovers before the apostles, who are seated on a bench that curves forward at the extremities. Giotto's design is novel for this subject, but in closely related themes it has very old, indeed probably Graeco-Roman, antecedents.

13 Elizabeth G. Holt, *A Documentary History of Art*, New York: Anchor, 1957, 253-266 (258). "Nel primo diremo de puncti, de linee et superficie piane. Nel secondo diremo de corpi chubi, de pilastri quadri, de colonne tonde et de più facce. Nel terzo diremo de le teste et capitelli, base, torchi de più base et altri corpi diversamente posti." G. Nicco Fasola, ed., Piero della Francesca, *De Prospectiva Pingendi*, Florence: Sansoni, 1942 [1480?], 65.

14 Marilyn Lavin, *Piero della Francesca: The Flagellation*, London: Allen Lane The Penguin Press, 1972. Creighton Gilbert discusses many powerful shifts in Piero's use of perspective within the True Cross series and elsewhere in his *Change in Piero della Francesca*, Locust Valley, N.Y.: Augustin, 1968.

15 Hubert Damisch, "La perspective au sens strict du terme," in Omar Calabrese (ed.), *Piero; Teorico dell'Arte* (Rome: Gangemi Editore, 1985), page 23.

16 Damisch, page 25:

> To eliminate this kind of aberration—strictly geometric by nature and by origin, as is apparent—it will suffice to hold to the "term" FG, directly opposite the eye at A, without touching the term FH perpendicular to it. Thence comes the rule expressed by Piero, who saw no better remedy for the aberration resulting from exceeding limits than to hold fast to an angle equal to two-thirds of a right angle, and whose two sides would form an equilateral angle with the line corresponding to the picture surface—the height

resulting from the top of the angle of vision (itself corresponding to the distance between eye and picture) being of a length inferior to that of the opposite side, that is, to the breadth of the picture.

17 Calabrese (ed.), *Piero*, 25-27.

18 Ibid.

19 Meiss, 52.

20 Norman Bryson, *Word and Image*, Cambridge: Cambridge University Press, 1981.

21 Another of Piero's treatises, the *Libellus de quinque corporibus regularibus* and his connection of the five regular bodies (tetrahedron, cube, octahedron, dodecahedron, icosahedron; all as inscribable within a sphere) to pictorializations, recalls Cézanne's insistence to Emile Bernard on the primacy of geometric figures to the structure of the painter's objects, "Traiter la nature par le cylindre, la sphère, le cône, le tout mis en perspective," "to treat nature through the cylinder, the sphere, the cone, the whole put in perspective," Paul Cézanne, *Correspondence*, ed. John Rewald, Paris: Grasset, 1935, 259.

22 Roberto Longhi, *Piero della Francesca*, Milan: Hoepli, 1943, 42.

23 Eugenio Battisti says of *The Finding of the True Cross*, for example, a panel where the Cross appears about as prominently as in any, "The Cross, which should indicate the center of

the scene ... is set obliquely, creating a central cesura that consequently divides the two groups of persons. ... Moreover, Piero, by using a horizon that is too low, succeeds in dispersing his persons on planes fairly close to each other, not being able to reduce their station effectively and suggesting a very limited depth. the result is an effect of juxtaposition without volume" (*Piero della Francesca*, Milano: Instituto Editoriale Italiano, 1971, 172).

[24] Hans Graber, *Piero della Francesca*, Basel: Schwabe, 1922, 22, 39.

[25] Laurie Schneider, "The Iconography of Piero della Francesca's Frescoes Illustrating the Legend of the True Cross in the Church of San Francesco at Arezzo," *Art Quarterly*, 23, 1969, 22-48. His order, of course, differs from that in the Golden Legend (24). In the Queen of Sheba panels Piero has Sheba remove only her crown, in distinction from Ghiberti's handling of the encounter on the bronze doors(27); as a figure "Sheba is associated with the Ethiopian Sibyl and Sibylla, the queen of the Ethiopians, thus emphasizing her prophetic character. The Sibyl is in turn associated with Helena." And all these women are expanded, framed, and figurally realized in the overarching typological association of Eve and the Virgin, provided here though not in other representations of the True Cross legend by Piero's inclusion of the Annunciation in one of his panels.

[26] Kenneth Clark, *Piero della Francesca*, London: Phaidon, 1969, 42.

173

27 Marilyn Lavin, *The Place of Narrative*, 188.

28 Carlo Ginzburg, *Indagini su Piero*, Turin: Einaudi, 1981, 32-40.

29 Vasari particularly notes the dress here, "the dresses of the Queen of Sheba's ladies, handled in a manner sweet and new," "gli abiti delle donne della reina Saba, condotti con maniera dolce e nuova."

30 These are carefully spelled out by Marilyn Lavin, *Piero della Francesca's* Baptism of Christ, New Haven: Yale University Press, 1981.

31 I adapt these details from the careful tracing of strands in the legend out of various sources by Esther Casier Quinn, *The Quest of Seth for the Oil of Life*, Chicago: University of Chicago Press, 1962, esp. 1-12. Her initial source is Richard Morris, ed., *Cursor Mundi*, Early English Text Society LVII, 78-91; LIX, 367-371 and 460-517; LXII, 945-947.

32 As several critics have remarked, Piero eliminated two usual episodes, the annunciation of the angel to Heraclius and the opening of the wall for Heraclius' entry into Jerusalem. Kenneth Clark indicates that Piero leaves out how the wood found by Jews is made into a cross, a scene depicted by Gaddi.

33 Giancarlo Maiorino links Piero's "geometrizing style" as anticipating Cubist landscapes, and the abstractions of Mondrian, especially through the blocking of color in *The Queen of Sheba Adores the Sacred Wood*. Giancarlo Maiorino, "The Legend of

Geometry Fulfilled," *Gazette des Beaux Arts* CVII, March, 1986, 112-117.

34 The meeting of Solomon and Sheba is rare, but it is slightly earlier parallelled on the bronze doors of Ghiberti. More commonly it appears, with a straightforward relation to the matrimonial conjunction, on marriage *cassoni* of the time. She is also, to be sure, included in one of Agnolo Gaddi's panels, *The Queen of Sheba Adores the Sacred Wood*, though the matching panel shows Solomon burying the wood rather than meeting Sheba.

35 As Thomas Martone puts it in his "Piero della Francesca e la prospettiva dell'intelletto," in Calabrese, *Piero*, page 176:

> In the fresco *The Meeting of Solomon and the Queen of Sheba* evidence occurs again of the intention to suppress the sense of depth by a systematic and selective suppression of linear structure. At first glance the two protagonists seem to be in the depth of an audience hall, but a closer look at their feet shows them to be standing in the first vestibule. Piero has completely masked the spatial depth created by the pose, through identifying the motif of the sleeve brocade with the motif of Solomon's mantle. At this point the forms of king and queen are so deeply compressed that the mind cannot distinguish the point nearest the eye from that farther away.

36 As Battisti says (146), "Piero introduces in the cycle a very ample survey of aspects of the various ages and sexes, from the pendulous breasts of Eve, stunned by old age, to the charm-

ing silhouette of the young girl beside her." And as he further remarks, "From the rude sylvan life of the Adamites we pass into the more solemn and courtly sphere of regality."

37 Yves Bonnefoy, "Time and the Timeless in the Quattrocento," in Norman Bryson, ed., *Calligram*, Cambridge: Cambridge University Press, 1988, 8-26. = "Le temps et l'intemporel" in Yves Bonnefoy, *L'improbable*, Paris: Mercure de France, 1980, 61-80.

38 As Roberto Longhi says of *The Annunciation*: "In fact the spectator cannot be imagined front and center in the composition, but to the right; so that, for being at an angle, the white column, a fourth and not final personage of the scene, comes somewhat to be centered" (54).

39 So Daniel Arasse notes in general ("Piero della Francesca, peintre d'histoire?" in Calabrese, 85-114):

Repetition and narrative doubling not only organize the general structure of the story divided into two different chapters; the very story of the Cross and its protagonists seems to obey the principle of doubling.

a) the Cross is buried twice (by Solomon and by the Jews after the Crucifixion) and it is twice brought to light (by the Jews before the Crucifixion, by Helen afterwards). It is the object of a double return to Jerusalem, and of these the last is itself doubled.

b) the actors are also occasion for striking rep-

etition: two imperfect visions (Constantine/ Heraclius), two reigning queens (Sheba, Helen), two emperors Constantine (the first Helen's husband, the second her son) ...[continued] Marilyn Lavin (*The Place of Narrative*, 175-176) sees the cross bar and ring on the upper story as a support for holding banners and tapestries during festival processions. Following her in reading the "barred" window as the "Fenestra Cancellata," a figure of the Virgin, would assimilate this quadrant to the whole. Yet the single, low bar seems ill-fitted to this function, and one could also take it as an inert feature, the better suited for complementarity, setting the whole in a picture that would be cosmic when taken together with the God of the upper left hand quadrant. Nor would these readings be mutually exclusive; combining them for their suggestiveness would in fact be in harmony with the richness of this whole cycle.

[40] Longhi, 42.

[41] Eve Borsook, *The Mural Painters of Tuscany,* Oxford: The Clarendon Press, 1980, 93.

[42] See Eleanor Winsor Leach, *The Rhetoric of Space: Literary and Artistic Representations of Landscape in Republican and Augustan Rome,* 79-80. "In 302 B.C., Pliny tells us, Fabius Pictor painted the walls of the Temple of Salus with megalographic compositions (*Natural History* 35.19). These paintings may have represented the military successes of L. Junius Bubucu-

lus, who dedicated the temple. M. Valerius Maximus Messala was said to have been the first person to display a wooden tablet depicting a battle when in 264 B.C. he exhibited the defeat of the Carthaginians and Hiero in Sicily at the side of the Curia Hostilia (Pliny, N.H. 35.22). Later in 190 B.C. Lucius Scipio angered his brother by displaying a picture of his Asiatic victory in which the son of Africanus had been taken prisoner. The substantial list of such celebratory paintings derives from several authors and extends from Rome's great Republican victories through the time of Caesar."

[43] René Girard's works generally, but especially *La Violence et le sacré*, Paris: Grasset, 1972; and *Des Choses cachées depuis la fondation du monde*, Paris: Grasset, 1978. Various refutations of overextensions in Girard's highly powerful thesis are to be found in Albert Cook, *Enactment: Greek Tragedy*, Chicago: Swallow, 1971, 145-146; *Myth and Language*, Bloomington: Indiana University Press, 1980, 285-286; *History/ Writing*, Cambridge: Cambridge University Press, 1988, 253. See also Irving Massey, *Find You the Virtue: Ethics, Image, and Desire in Literature*, Fairfax, Va.: George Mason University Press, 1987, 124-130; 185-186.

[44] The unjust case of the indiscriminate slaughter of the handmaids who had slept with Penelope's suitors at the conclusion of the Odyssey forces us to mediate between aesthetics and ethics.

[45] See Leo Bersani and Ulysse Dutoit, *The Forms of Violence*, Berkeley: The University of California Press, 1985. Bersani

challengingly detaches the aesthetic elements from the Assyri-
an frieze, on the one hand emphasizing the similarities between
those sculptors and such as Uccello. On the other hand he ana-
lyzes the sado-masochistic elements in the pleasure of looking,
effectually putting the psychodynamic activity of the spectator
into convergence with the public and jingoistic. His approach
tends to play down the differences between these sculptors and
the aestheticization of a Leni Riefensthal, and even to mute the
opposition between the foregrounding of violence-worship at
Nürnberg rallies and the actual violence of battle—in, say, the
photographs of a Matthew Brady. Aesthetic distance, too,
becomes an overriding category that tends to play down the
opposition between a worshipful Riefensthal (he quotes her lat-
er denials) and the controlled and distanced horror of Alain Res-
nais's film about the concentration camps, *Night and Fog.*

It is hard to see the function in Assyrian friezes that
makes them convey the muting and modification I see in Pie-
ro's battle panels, though Bersani makes that leap, "Assyrian
art does not propose a myth of nonviolence. Instead, in the
course of allowing us (of forcing us) to see, even to enjoy, exam-
ples of the violence in human history inescapably implicates us,
it also stimulates those psychic dislocations of mobile desire
which may help to forestall a destructive fixation on, and
complicity with, anecdotal violence." (56). This intricately
reconstructs a possible psychology for the modern viewer, but it
overlooks, and to some degree cancels (or at least brackets) the
celebratory and participatory function which alone can explain
the production of the original friezes in their own cultural con-
text. No forestalling there! Still, his general aesthetic descrip-
tion well focusses what is going on in such representations, and

not only the Assyrian ones: "a playful puzzle of forms in the sculptural representation of this slaughter offers the spectator an alternative mode of agitation; the scene is calculated not to produce 'esthetic calm,' but rather to make us enjoy a kind of esthetic 'violence': the agitations of multiple contacts producing multiple forms."(20)."In the Assyrian palace reliefs, the very centers of anecdotal violence decenter themselves"(39).

46 How thought relates to the location of the body is a question raised in Descartes, at least by implication, and finding a long history in the apriori of Kant, the meditations of Valéry, and the intentional-constructions of Husserl. Nor is the later thought of Wittgenstein divorced from such questions. Peter Baker applies comparable considerations about the body to poetry, in *Obdurate Brilliance: Exteriority and the Modern Long Poem*, The University of Florida Press, 1991.

47 Eve Borsook, *The Mural Painters*, 95. "Popular pilgrims' guides of the time took particular care in tracing the origin of the Holy Wood from Jerusalem to Hebron, and Piero's scenes represent many of these holy places: Adam's grave, the bridge at Kidron, the probatic pool (where Solomon buries the wood), the spot where Helena found the True Cross, and Jerusalem itself, ... as well as the Virgin's house at Nazareth."

48 One is in the Pushkin Museum, Moscow; the other, in the Richmond Museum. It should be noted that this is not listed in either instance as the Battle at the Ponte Milvio, perhaps because Claude did not locate it at the edge of Rome, the actual site of the bridge. But a victory of Constantine over Maxentius

at a bridge can only refer to that capital battle.

[49] Battisti, 197. He cites Warburg's attribution of the lance-holding knight to a similar figure on the Arch of Constantine in Rome.

[50] Geneviève Rodin-Lewis sees this as a severed head, and one she analyzes as entering a mapping of the Golden Section in the panel. She identifies it as the head of the son of Chosroes. Geneviève Rodin-Lewis, "De la Signature au signe, sur un détail méconnu des fresques d'Arezzo," *Rinascimento*, Ser. 2, No. 27, 239-258.

[51] John Pope-Hennessy, *Paolo Uccello*, London: Phaedon, 1969, 12-13.

[52] There is, according to Pierre Francastel (*Peinture et société*, Lyon, 1951), a vanishing perspective in the foreground, while in the background a still medieval compartmentalized perspective is used. A summary and applied analysis is given by Lucia Tongiorgi Tomasi in *Paolo Uccello*, Milan: Rizzoli, 1971.

[53] Michael Fried, *Courbet's Realism*, Chicago: the University of Chicago Press, 1990, 17, 21. Fried goes on to point out that in his *livret* for the painting, David produced a speech of 170 words for Hersilia, the wife who is trying here to hold back Romulus.

[54] These are all discussed in Gisela Goldberg, *Die Alexander-schlacht und die Historienbilder Herzog Wilhelms IV*, Munich:

Hirmer, 1983.

55 As notably in the acute and subtle discriminations of Jean-François Lyotard, *Discours, Figure*, Paris: Klincksieck, 1971.

56 Creighton Gilbert, *Change in Piero della Francesca*, 1-45. Gilbert expands on conjectures about the deliberateness of Piero's work over long time.

57 For a discussion of this term and its implications for theory in the writings of Giorgio Vasari, Federico Zuccaro and G. P. Lomazzo, see James Mirollo, *Mannerism and Renaissance Poetry*, New Haven: Yale University Press, 1984, 13-26.

58 Adrian Stokes, *Critical Writings*, New York: Thames and Hudson, 1978; *The Quattrocento*(1932), Vol. 1, 29-180; "Reflections on the Nude," Vol. 3, 303-309.

59 Maurice Merleau-Ponty, *Le Visible et l'invisible*, Paris: Gallimard, 1964.

60 Roberto Longhi, 41.

61 Bernard Berenson, *Piero della Francesco or the Ineloquent in Art*, London: Chapman & Hall, 1954, 3.

62 Alessandro Angelini, *Piero della Francesca*, Harper (Scala), 1985, 3, citing Vasari. Roberto Longhi (14) well indicates Piero's synthesizing power:

There can be no doubt that Piero, having decided to

embark on a course that was magisterial and at the
same time personal, held in view not only modern
instances like the intense plastic manner of Paolo di
Dono, the eloquent medieval classicism of Nanni di
Banco, Lorenzo, and Michelozzo, as well as the shad-
owy renascence of Masolino, an exquisite mixture of
the Sienese, the medieval, the gothic, and that which
is related to it, though more subtly, the manner of a
still young Domenico Veneziano; but he also held in
view the instances of a Gothicism that at the same
time dominated the walls of Florence.

63
Michael Baxandall, *Painting and Experience in Fifteenth Century
Italy*, Oxford: Oxford University Press, 1972.

64
Fasola, ed., *De Prospectiva Pingendi*, 63; Holt, 256-257.

65
Michael Baxandall, *Patterns of Intention: on the Historical
Explanation of Pictures*, New Haven: Yale University Press,
1985, 112-113.

66
In the Sansepolcro Resurrection, however, the greens, browns,
and reds are all subdued.

67
Battisti, 172-173. Alberti was working at the same time as Pie-
ro on the Tempio di Malatesta in Rimini. And as Eve Borsook
points out (*The Mural Painters of Tuscany*, 97), his palette had
profound resources. He was original in mixing for his frescoes a
tempera (pigments soaked in casein, oil or egg) achieving a bril-
liance usually impossible for fresco, especially in red lakes and

transparent greens. For limited and common pigments he used "bianco di Sangiovanni, finely ground; two yellow ochres—the tones of which were varied according to the amounts of white, green or black added; four reds (burnt ochre, sinope, cinnabar, and hematite); three greens (malachite, *terra verde* and copper resinate); azurite and vegetable black."

68 Sano di Pietro, however, has a Madonna della Misericordia (now in a private collection) of the late 1440's, possibly for a convent, with the figures comparably disposed. All are Clare sisters in habits, except two youths in front. All kneel and face at an angle that gives us part of their faces as they look up to the sheltering Virgin.

69 I am here following Millard Meiss, "Jan van Eyck and the Italian Renaissance," *Venezia e l'Europa. Atti del XVIII congresso internazionale di storia dell'arte, 1955*, Venice, 1956, 58-69; reprinted in *The Painter's Choice*, 19-62.

70 Michael Baxandall notes a comparable array of eye positions in the *Baptism:* "Of three very kindred heads, one catches our eye, one registers frontal straight attention, one turns its body and with a gesture refers to the central scene. And at an even more subtle and Pieresque level the middle Angel directs us to the fact of Baptism by completing a triplet of whites with Christ, at the centre, and the bending man on the right" (*Patterns of Intention*, 129-130).

71 As for the uniqueness of this work, Meiss's comments are apposite (95), "The only earlier paintings which resemble it ... are a

fresco representing S. Giovanni Gualberto enthroned amidst saints and *beati*, painted by Neri di Bicci in San Pancrazio in 1454/5, and possibly reflecting a lost work by a greater master, and Fra Angelico's altarpiece for Bosco ai Frati, wherin this painter's usual canopied throne has been so greatly enlarged that it resembles the domed apse of a church. In the Brera Altarpiece Piero abandoned, in favor of a single rectangular panel, the polyptych form which he had preserved for so many years ... For the first time in an Italian altarpiece a church is introduced as the setting for the Madonna and saints ... The monumentality of the figures in the Brera panel is to some extent absorbed by the even greater monumentality of the church."

[72] Philip Hendy (*Piero della Francesca and the Early Renaissance*, London: Weidenfeld & Nicholson, 1969, 17) stresses the painter's recourse here to *azzuro oltremare*, "Even in their symbolism Piero's colors are related to the sky"—except that, as I have been urging, it is often sub-symbolic.

[73] See Emanuel Winternitz, *Musical Instruments and Their Symbolism in Western Art*, New Haven: Yale University Press, 1979; and Reinhold Hammerstein, *Die Musik der Engel*, Bern: Francke, 1962.

[74] Here, as elsewhere, I take my lead from Marilyn Lavin, *The Baptism of Christ*, New Haven: Yale University Press, 1981, 3-39. As she says (5) "More usual in panoramic vistas are foreground figures places ... parallel to the picture plane ... The foreground of Piero's design ... is uninhabited, with the main

figures placed some distance behind the picture plane. It is precisely this empty area that gives the illusion of accessibility, and yet in psychological terms creates a kind of no-man's-land that bars our entry."

[75] Marilyn Lavin, *The Flagellation*, 76.

[76] Marilyn Lavin (*Baptism*, 71-105) reads specific references to wedding customs, and to the Wedding at Cana, into the attributes of these angels, their triad recalling that of the Graces. The effect is the stronger if the references lose their specificity and give a general air of such celebrations to this particular scene. For caveats against too elaborately specific a repertoire of iconographic readings, especially in the context of the developing power of converging multiple significations very soon after Piero's time, see Albert Cook, *Changing the Signs: the Fifteenth Century Breakthrough*, Lincoln: The University of Nebraska Press, 1985.

[77] Kenneth Clark, *Piero della Francesca*, 29.

[78] I am here developing a point made by Norman Bryson (personal communication).

[79] It is striking that Kant, writing about aesthetics but not about painting, retains a version of this assumption, connecting the military to the sublime (*Kritik der Urteilskraft*, I, II, 29), declaring the inferiority of the statesman to the general "Aesthetic judgment decides for the latter ... Even war, when it is conducted with the order of piety [Heiligachtung] of bourgeois justice,

has something sublime about it, and at the same time makes
the thinking [Denkungsart] of the people who carry it out in
this fashion the more sublime, the more dangers there are in
the undertaking."

[80] Harry Berger, *Second World and Green World*, Berkeley, University of California Press, 1988, 412.

[81] For a summary and critique of related problems, see W. J. T. Mitchell, *Iconology*, Chicago: University of Chicago Press, 1986.

[82] Rudolf Arnheim, "The Unity of the Arts: Time, Space, and Distance," in *Yearbook of Comparative and General Literature* 25 (1976): 7-12.

[83] See Albert Cook, *Dimensions of the Sign in Art*, Hanover: University Press of New England, 1989.

[84] For some discussion of these in various cultures, see "The Modification of the Narrative in Art," *Dimensions of the Sign in Art*, 205-214. Simply sequential but elaborate series of narrative panels are found in Babylonian, early Roman, and Etruscan settings (as well as Greek and Egyptian): Richard Brilliant, *Visual Narrative, Storytelling in Etruscan and Roman Art*, Ithaca: Cornell University Press, 1984.

[85] The constructive focus pervades Richard Wollheim's *Painting as an Art*, Princeton: Princeton University Press, 1987, even though he has argued effectively against the exclusions of Gombrich. Still, Wollheim does sensitively trace the visual

communication of significances. His "seeing-in" (46-79) and his "expressive perception" form constituents in some ways of what I call "immersion." Rudolf Arnheim, with a proper choice of focus for his engaging subject, writes mostly about the constructive in *Art and Visual Perception*, Berkeley: University of California Press, 1974.

86

The attribution of this painting to Piero is in some doubt, but I believe what I say about it will hold in any case, since I am reflecting on it generally rather than relating it to his other work.

87

Siegfried Giedion, *Time, Space, and Architecture*, Cambridge: Harvard University Press, 1967, 41-107.

88

Citations are from Maurice Merleau-Ponty, *L'Oeil Ecoute*, Paris: Gallimard, 1986 [1964]. "C'est en prêtant son corps au monde que le peintre change le monde en peinture. Pour comprendre ces transubstantiations, il faut retrouver le corps opérant et actuel, celui qui n'est past un morceau d'espace, un faisceau de fonctions, qui est un entrelacs de vision et de mouvement (16)." "'la nature est à l'intérieur,' dit Cézanne. Qualité, lumière, profondeur, qui sont là-bas devant nous, n'y sont que parce qu'elles éveillent un écho dans notre corps, parce qu'il leur fait accueil ... Alors paraît un visible à la deuxième puissance, essence charnelle ou icône du premier"(22). "Cette vision...étant pensée unie à un corps, elle ne peut par définition être vraiment pensée"(54). "Ce qui donne le mouvement, dit Rodin, c'est une image où les bras, les jambes, le tronc, la tête sont pris chacun à un autre instant, qui donc fig-

ure le corps dans une attitude qu'il n'a eue à aucun moment, et impose entre les parties des raccords fictifs." (78-79) [citing Rodin, *L'art*, ed. Paul Gsell, Paris, 1911].

89 Gilles Deleuze, *Cinema 1: L'Image-mouvement; Cinema 2:L'Image-temps*, Paris: Minuit, 1983; 1985. =Hugh Tomlinson and Robert Galeta, tr., *The Movement-Image; The Time-Image*, Minneapolis: University of Minnesota Press, 1986; 1989.

90 "Placer la Nature au fond de l'Histoire," Roland Barthes, *Mythologies*, Paris: Seuil, 1957, 196.

91 See Susan Sontag, *On Photography*, New York: Dell, 1977, 32-48. As she quotes Arbus, "You see someone on the street, and essentially what you notice about them is the flaw."

92 This is the interpretation of Mariani (*Scenografia italiana*, 1930) and of Krautheimer (*Gazette des Beaux Arts*, 1948), as cited by Oreste del Buono, *L'Opera completa di Piero della Francesca*, Milan: Rizzoli, 1967, 104. The mysterious closedness, the variation of the detail, and the very eclecticism of this painting would also remove it from the specificity of an illustration for such an architectural textbook as those of Laura or Alberti, the interpretation of many commentators as summarized by del Buono.

93 Paul G. Bahn and Jean Vertut, *Images of the Ice Age*, New York: Facts on File, 1988. They cite worked bones and teeth more than a hundred thousand years old from German, Hungarian and French sites (71) and engraved bones three hundred

thousand years old from Germany and France (80). I am indebted for this reference, and for the information, to Randall White. As he says in "Visual Thinking in the Ice Age," *Scientific American,* July, 1989, 92-99, "Those who look for prototypes tend to take for granted the notion that the earliest art must be simple and child-like. The archeological record of the Aurignacian suggests that the earliest drawing is just that. The contemporaneous sculpture, however, is lifelike and expressive. Perhaps it was easier to reduce an animal to a three-dimensional scale model than it was to depict it in two dimensions. It seems to have taken thousands of years for early artists to develop the conventions and tricks of two-dimensional representation seen at sites such as Lascaux, which was painted 17,000 years after the first Upper Paleolithic images were created" (98).

94

Naomi Schor, *Reading for Detail: Aesthetics of the Feminine,* New York and London: Methuen, 1987. Especially "Truth in Sculpture: Duane Hanson," 131-140.

95

Irving Feldman, *All of Us Here,* New York: Viking, 1986.

96

Ernest B. Gilman, *Iconoclasm and Poetry in the English Reformation: Down Went Dagon,* Chicago: University of Chicago Press, 1986: (1-2). See Also John B. Erwin, *Remember the Body,* New York: Peter Lang, forthcoming.

97

Albert Cook, *The Classic Line,* Bloomington: Indiana University Press, 1966, 277.

98 Martin Heidegger, *Der Ursprung des Kunstwerkes*, Stuttgart, Reklam, 1960, 9. "Kunstwerke sind jedermann bekannt. Bau- und Bildwerke findet man auf öffentlichen Plätzen, in den Kirchen, und in den Wohnhäuser angebracht."

99 The book of Hölderlin carried in the poet's knapsack (10), *pace* Heidegger,is not a "thing" in this sense: its visible properties do not embody its art function.

100 "Die Welt gründet sich auf die Erde, und Erde durchragt Welt" (50).

101 "Das Zeug gibt in seiner Verlässlichkeit dieser Welt eine eigene Notwendigkeit und Nähe" (45).

102 "In der Innigkeit des Streites hat daher die Ruhe des in sich ruhenden Werkes ihr Wesen" (52).

103 *"Schönheit ist eine Weise wie Wahrheit als Unverborgenheit west"* [italics Heidegger's] (61).

104 "Das Wissen das ein Wollen, und das Wollen das ein Wissen bleibt, ist das ekstatische Sicheinlassen des existierenden Menschen in die Unverborgenheit des Seins" (76).

105 David E. Wellberry, *Lessing's* Laocoon, *Semiotics and Aesthetics in the Age of Reason*, Cambridge, 1984, 203. Wellberry applies the terms of Hjemslev & Morris to Lessing's *Laocoon*. "The syntax [derived for Laocoon] of the plastic arts is the set of spatial relations between real things" (127).

106 Claude Lévi-Strauss, "Le dédoublement de la représentation dans les art de l'Asie et de l'Amérique," *Anthropologie structurale*, Paris: Plon, 1958, 269-294.

107 Franz Boas, *Primitive Art*, New York: Dover, 1955 [1927], 94-95 (citing evidence from A.L. Kroeber).

108 Here I am following the general discussion in Giedion, *Space, Time, and Architecture*, Part II.

109 David Freidel and Linda Schele, "Symbol and Power: A History of the Lowland Maya Cosmogram," in Elizabeth P. Benson and Gillett G. Griffin, editors, *Maya Iconography*, Princeton: Princeton University Press, 1988, 44-93.

110 Christos Doumas, *Thera, Pompeii of the Ancient Aegean*, London: Thames and Hudson, 1983. The interaction of nature and culture in a represented landscape is already in itself a complicated affair, as Harold Baker observes, "Landscape is determined by two implicit tropes in which it is involved: one of antithesis between itself and an enclosed, inward-turning human space, and one of metonymy with the cosmos or a totality of relationships external to the human. These two tropes clearly reinforce and intensify one another: it is landscape's *relative* externality to the human that provokes its elevation to a symbol of the infinite non-human, and its patent vastness that makes it initially seem to negate human presence." (Harold Baker, *Nineteenth-Century Landscape and the Scene of Writing*, forthcoming.) The cultural specificity of the perception of space (and time), and hence of the representa-

tion of landscape, is well pointed up by the difficulty of ascertaining how far Baker's analysis, intended for nineteenth-century landscape as his subject indicates, would apply to such landscapes as those of the seventeenth century in Holland, which may be still different in representational structure and ontological feeling from those of Brueghel a century earlier, to say nothing of landscapes in the mural painting of Pompeii, and Thera.

[111] Vincent Scully, *The Earth, The Temple, and the Gods*, New York: Praeger, 1969.

[112] Pietro Scarduelli, "Symbolic Organization of the Space and Social Identity in Alor (Indonesia)," abstract of a paper given on September 10, 1990, at the World Anthropological Inter-Congress, Lisbon. In Scarduelli's analysis the village has five rectangular sections, with a house at the edge of each for meetings. Three of the five have mounds of stone used for the sacrifice of enemies. Each section defines its constituent groups. Symbolic meanings are assigned to structural features of houses, including shape, and references to genealogy are incorporated into these spaces, as are social hierarchies.

[113] Lévi-Strauss, "Les organizations dualistes existent-elles," *Anthropologie structurale*, 147-180.

[114] Yolotl G. Torres, "Violence in Mexican Prehispanic Myths," paper given at Lisbon Inter-Congress, September, 1990.

[115] Manfredo Tafuri, *La sfera e il labirinto*, Turin: Einaudi, 1980,

36. "Ciò che va posto subito in chiaro, è che tutto quel frazionare, distorcere, moltiplicare, scomporre, al di là delle reazioni emotive che può sollecitare, altro non è che una critica sistematica al *concetto di luogo* compiuto con gli strumenti della comunicazione visiva."

116 Tafuri, 40-41. I owe the references to Tafuri and Eisenman, and the general indication of this line of discourse, to Michael Stanton.

117 Robert Eisler, *Weltenmantel und Himmelszelt*, Munich: Beck, 1910.

118 Giedion, 45.

119 Giedion, 69.

120 Giedion, 254

121 Peter Eisenman, "Real and English: The Destruction of the Box I," *Oppositions*, n. 4, 1974, 6-34.

122 Stanley Tigerman, "The Meaning of Architecture," in Marco Diani and Catherine Ingraham, eds., *Restructuring Architectural Theory*, Evanston, Illinois: Northwestern University Press, 1989.

123 I owe the demonstration and analysis of these properties in Murray's paintings to a lecture by Robert Storr, "Breaking Up Is Hard to Do, Elizabeth Murray and Painting," Brown

University, May 25, 1991.

124 Norma Kassirer, "The Sublimity of the Word," *Buffalo Spree*, Vol. 24, No. 1, Spring, 1990, 80-83.

125 Giedion, 21.

126 Veronese's painted villa is so characterized by James S. Ackerman, *The Villa: Form and Ideology of the Country House*, Princeton: Princeton University Press, 1990.

127 Veronese adds to Palladio, whose effect Rodolfo Palluchini characterizes [*Gli Affreschi di Paolo Veronese a Maser*, Bergamo, Istituto Italiano d'Arte Graffiche, 1939, v.]: "il ritmo spaziale palladiano mette in contatto lo spazio interno dell'edificio con quello esterno, illimitato, della natura." "The Palladian spatial rhythm puts the internal space of the building in contact with the space which is external and unlimited, the space of nature" As he says further (xii), "Nello spazio luminoso e nell'ebbrezza del canto scoperto del colore, i problemi dell'estetica manieristica si sono trasformati e capolvolti."

128 Pignatti cites the theories of Medea, Ivanoff and Cooke that the overall theme of Maser is celestial harmony. (Terisio Pignatti, *Veronese*, Venice: Alfieri, 1976, I, 60). He speaks (48) of "a certain play of angling that Paolo gives to the foreshortened figures," "un certo gioco di angolazioni che Paolo dà alle figure in scorcio."

129 Irving Lavin, *Bernini and the Unity of the Visual Arts*, 79.

130 As Lavin says (43), Bernini is reported to have praised the Carracci for avoiding a single point of view. Similarly, the two devout figures in the Raimondi chapel of San Pietro in Montorio, who represent those entombed, one reading and the other in a contemplative posture, are not set to perceive the Ecstasy of Saint Francis at the center of their chapel, though they are not blocked from doing so. They are seated, at the sides, while St. Francis is erect, in levitation, at the center.

131 Irving Lavin, 139-140.

132 Howard Hibbard, *Bernini*, Harmondsworth: Penguin, 1965, 131.

133 Jacques Lacan *Encore: Séminaire XX*, Paris: Seuil, 1975.

134 Ibid, 40.

135 "Cette vérité qu'il y a à chaque franchissement d'un discours à un autre" (21).

136 "La stricte équivalence de topologie et structure" (14).

137 "Le signifiant ... est à structurer en termes topologiques" (22).

138 Luce Irigaray, *Ce Sexe qui n'en est pas un*, Paris: Minuit, 1977, 83-102.

139 Santa Teresa de Jesus, "Conceptos del Amor de Dios," *Obras*,

Editorial: Madrid, 1951 [1577?], 661-730.

140

Irigaray, 95.

141

"Là où est l'être, c'est l'exigence de l'infinitude" (15). This pronouncement turns Parmenides in the direction of Heidegger, with a density perhaps too allusive.

142

"Il y a un trou, et ce trou s'appelle l'Autre ... l'Autre en tant que lieu où la parole, d' être déposée—vous ferez attention aux résonances—fonde la vérité, et avec elle le pacte qui supplée à l'inexistence du rapport sexuel, en tant qu'il serait pensé, pensé pensable autrement dit, et que le discours ne serait pas réduit à ne partir ... que du semblant" (103).

143

For a discussion of this work and others, see "The 'Meta-irony' of Marcel Duchamp" in Albert Cook, *Dimensions of the Sign in Art,* 151-177; and Dalia Judowitz, "Rendezvous with Marcel Duchamp: *Given*" in R.E. Kuenzli and F.M. Naumann, eds, *Marcel Duchamp: Artist of the Century,* Cambridge: MIT Press, 1989, 184-202.

144

For a full discussion of this use of mirrors in art works and elsewhere see Albert Cook, "The Wilderness of Mirrors," *Dimensions of the Sign in Art,* 62-83.

145

Keith Cohen, "Pleasure of Voicing: Oral Intermittences in Two Films by Alain Resnais," *L'Esprit Créateur,* Vol. XXX, No. 2, Summer, 1990, 58-67.

146 George R. Kernodle, *From Art to Theater: Form and Convention in the Renaissance*, Chicago: University of Chicago Press, 1944.

147 Paul Schmidt, a friend of Robert Wilson, relates his work to the *tableau vivant* tradition of the late nineteenth century.

148 Deleuze, *L'Image-mouvement*, 68.

149 Thomas Rosenmeyer, *The Art of Aeschylus*, Berkeley: The University of California Press, 1982, 54.

150 Erwin Panofsky, "Style and Medium in the Motion Pictures," in Daniel Talbot, ed., *Film, an Anthology*, Berkeley: University of California Press, 15-32 (18).

151 "L'image-mouvement a deux faces, l'une par rapport à des objets dont elle fait varier la position relative, l'autre par rapport à un tout dont elle exprime un changement absolu. Les positions sont dans l'espace, mais le tout qui change est dans le temps. Si l'on assimile l'image-mouvement au plan, on appelle cadrage la première face du plan tournée vers les objets, et montage l'autre face tournée vers le tout." Deleuze, *L'Image-temps*, 50-51.= *The Time-Image*, 34.

152 Sergei Eisenstein, *Film Form; Film Sense*, New York: Meridian, 1957.

153 Christian Metz, *Film Language*, New York: Oxford, 1974. One might in fact qualify Metz's statement. A single shot

does indeed have constituents whose relations among them-
selves do produce something analogous to a syntax. But he is
right to stress the relation of one whole shot to another, as
Eisenstein did, and to assert the primacy of montage over the
diegesis of narrative—as in painting.

154 "Nous nous trouvions devant six types d'images sensibles
apparentes, et non pas trois: *l'image-perception*, *l'image-
affection*, *l'image-pulsion* (intermédiaire entre l'affection et
l'action), *l'image-action*, *l'image-réflection* (intermédiaire entre
l'action et la relation), *l'image-relation*." Deleuze, *L'Image-
temps*, 48 = *The Time-Image*, 32.

155 On these general conditions, see Rudolf Arnheim, *Film as Art*,
Berkeley: University of California Press, 1964, 21-34.

156 Gilles Deleuze, *L'Image-mouvement*, 27, "le cadre assure une
déterritorialisation de l'image."

157 As Robbe-Grillet says of his collaboration, "I knew Resnais'
work and admired the uncompromising rigor of its composi-
tion. In it I recognized my own efforts toward a somewhat
ritual deliberation, a certain slowness, a sense of the theatri-
cal, even that occasional rigidity of attitude, that hieratic
quality in gesture, word and setting which suggests both a
statue and an opera. Lastly, I saw Resnais' work as an
attempt to construct a purely mental space and time—those
of dreams, perhaps, or of memory, those of any affective
life—without worrying too much about the traditional rela-
tions of cause and effect, or about an absolute time sequence

in the narrative." (Alain Robbe-Grillet, *Last Year at Marienbad*, New York: Grove Press, 1962, 8-9). And further, "The essential charateristic of the image is its presentness. Whereas literature has a whole gamut of grammatical tenses which makes it possible to narrate events in relation to each other, one might say that on the screen verbs are always in the present tense." [Freud makes a similar point about dreams.—A.C.] (12).

158 "Pour Vertov le photogramme n'est pas un simple retour à la photo: s'il appartient au cinéma, c'est parce qu'il est l'élément génétique de l'image, ou l'élément differentiel du mouvement. Il ne 'termine' pas le mouvement sans être aussi le principe de son accélération, de son ralentissement, de sa variation." *L'Image-mouvement*, 120. Deleuze is here citing Annette Michelson.

159 Rudolf Arnheim, *Film as Art*, 118.

160 See Albert Cook, "The Dimensions of Color," *Dimensions of the Sign in Art*, 39-61.

Index

LITERATURE AND THE VISUAL ARTS:
New Foundations

Offering distinguished works of scholarship and criticism on the interrelationship of literature and the visual arts, the series reflects the rich diversity of subjects and approaches in this developing field. Our authors contribute to an expert's understanding of their chosen topic. At the same time, they speak to readers, lay and professional, with a more general interest in the area. Ideally — and this is the thrust of the phrase "New Foundations" in our series title — works published under this imprint focus on the ways their particular concern leads us to rethink the basic questions of comparative study between the arts, challenging the reader volume by volume continually to remap the grounds, historical and theoretical, on which such inquiry can take place at all.

Monographs of at least two hundred pages are invited by the General Editor, New York University, Department of English, 19 University Place, 2nd Floor, New York, New York 10003. Detailed proposals and sections of works in progress as well as complete manuscripts are welcome.